DEPARTURES

JOHN BALDESSARI

UTA BARTH

SHARON ELLIS

11 DEPARTURES

JUDY FISKIN

Artists

at the Getty

LISA LYONS

ALISON SAAR

Artists' Portraits by Grant Mudford

MARTIN KERSELS

ADRIAN SAXE

JOHN M. MILLER

The J. Paul Getty Museum, Los Angeles

RUBÉN ORTIZ TORRES

STEPHEN PRINA

LARI PITTMAN

CHRISTOPHER HUDSON, Publisher
MARK GREENBERG, Managing Editor
TOBI LEVENBERG KAPLAN, Editor
LORRAINE WILD, BELE DUCKE, AMANDA WASHBURN, Designers

Printed by LITHOGRAPHIX, Los Angeles

Exhibition held at the J. Paul Getty Museum
February 29 through May 7, 2000

Library of Congress Cataloging-in-Publication Data
Lyons, Lisa.
 Departures : 11 artists at the Getty / Lisa Lyons.
 p. cm.
 ISBN 0-89236-582-x
 1. Art, American—California—Los Angeles—Exhibitions. 2. Art, Modern—20th
 century—California—Los Angeles—Exhibitions. I Title: 11 artists at the Getty.
 II. J. Paul
 Getty Museum. III. Title.
 N6535.L6 L96 2000
 709'.73'07479494—dc21

 99-057616

CONTENTS

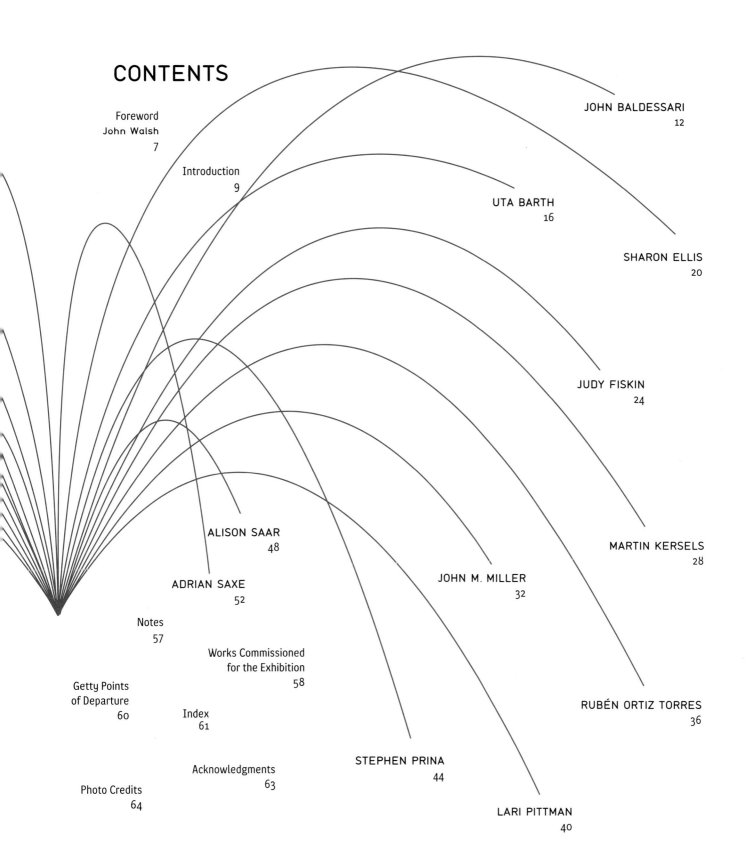

Foreword
John Walsh
7

Introduction
9

JOHN BALDESSARI
12

UTA BARTH
16

SHARON ELLIS
20

JUDY FISKIN
24

MARTIN KERSELS
28

JOHN M. MILLER
32

RUBÉN ORTIZ TORRES
36

LARI PITTMAN
40

STEPHEN PRINA
44

ALISON SAAR
48

ADRIAN SAXE
52

Notes
57

Works Commissioned
for the Exhibition
58

Getty Points
of Departure
60

Index
61

Acknowledgments
63

Photo Credits
64

The Getty's most important visitors may be artists. We have a lot of them these days, now that the Getty Museum sits on a hill in full view of the city, and now that our temporary exhibitions are so much more frequent and conspicuous. Artists are perceptive and demanding visitors, and, sometimes, when our works of art have given them joy, or anger, or ideas, or courage, they let us play one of the oldest and most serious roles a museum can have: to stimulate the making of new art.

Since the Getty Center opened two years ago, we have found many ways to involve artists in our work, especially Los Angeles artists. This involvement is particularly valuable for a museum whose collection stops around 1900 (except for the work of photographers), for otherwise we might distance ourselves from the relentless evolution of artistic ideas in the present day and fail to connect with an entire audience. Small exhibitions place contemporary work in the context of our collections. Lectures and discussions link artists' interests with our concerns for scholarship, conservation, and the cultural life of Los Angeles. Our continuing project of commissioning new works for public places at the Getty Center is something visitors can't miss, especially now that a 45-foot-high sculpture by Martin Puryear greets them as they get off the tram.

Departures, true to its title, moves off in a new direction. These commissioned works are not conceived for specific places but instead generated by artists' encounters with the Getty and its works of art. Since none of the works has been finished as I write, I can only describe our hopes for the show: that these eleven artists will have stretched and perhaps surprised themselves in this project, that they will stretch us in turn, and that we will all look at older, more familiar works of art with new eyes, new ideas.

Lisa Lyons, who has a rare empathy with artists, has devoted her career to getting complex projects accomplished. She has our admiration and warm thanks for having proposed this exhibition and having carried out every aspect of it—from the first ideas to choices of artists, to the final installation—including this catalogue. She was abetted by Deborah Gribbon and Barbara Whitney, deputy and associate directors respectively, and by the Exhibitions Department under Quincy Houghton; and she was aided from first to last by a superb Getty team of conservators, educators, registrars, preparators, exhibition designers, editors, book designers, production coordinators, and public affairs people. They dealt gamely with more uncertainties than are usual in a museum that normally shows the work of dead artists, and I am grateful to them all.

John Walsh
Director

Meditation on a Jade Mountain

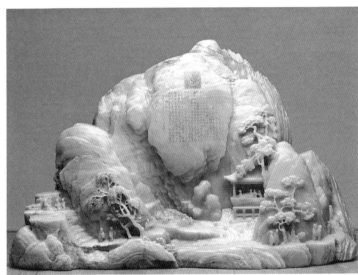

Jade Mountain Illustrating
the Gathering of Poets at the Lan
T'ing Pavilion, 1784
Jade, overall 57.2 x 97.5 cm
(22½ x 38⅜ in.)
Minneapolis Institute of Arts

I vividly remember my first museum visit. Sitting in a sky-blue metal stroller, I was wheeled through the entrance of the old Walker Art Center in Minneapolis. The front guardrail of my chariot was strung with brightly colored wooden beads meant to keep chubby fingers and a curious mind occupied, but that day the beads held little interest. There was something far more captivating to look at: the *Jade Mountain*. The towering pile of carved green stone that had once served as a centerpiece on the dinner table of Thomas Barlow Walker, the museum's founder, was the most intriguing and wonderful thing that I had ever seen, and the sheer joy of looking at it is still etched in my brain. After that day, whenever I was loaded into the Oldsmobile for an outing, I hoped that the building with the marvelous green mountain would be our destination.

Evidently, the *Jade Mountain* had that effect on a lot of people, and to this day, visitors who have not been to the Walker for several years inquire after it. But it is no longer there. In 1976, when the museum decided to focus strictly on modern and contemporary art, the mountain was transferred across town to the encyclopedic collection of the Minneapolis Institute of Arts. By that time, I was a curator at the Walker, and one day, a few weeks after the mountain's departure, I watched as a group of women of a certain age entered what had been the Jade Gallery. The mountain had long stood in a display case recessed in the north wall of the room. Now the case was gone. In its place, a solid, blank wall awaited the installation of some photographs.

FRANZ MARC
(German, 1880–1916)
Die grossen blauen Pferde
(The Large Blue Horses), 1911
Oil on canvas, 105.5 x 181.1 cm
(41⁵⁄₁₆ x 71¼ in.)
Collection Walker Art Center,
Minneapolis, 42.1
Gift of the T. B. Walker Foundation,
Gilbert M. Walker Fund, 1942

As her friends looked on with worried expressions, one of the ladies put her ear to the wall and rapped on it with her knuckles. "Perhaps it's still back there," the hopeful look on her face said. I understood. She, too, had been smitten by the mountain. I approached her and explained that a ten-minute drive would put her in the presence of her beloved celadon-colored sculpture. She seemed more wistful than relieved, and then, choosing her words carefully, she asked with some trepidation, "Is our wonderful *Blue Horses* still here?" I assured her that the Franz Marc painting was indeed on view in Gallery 4, and she and her companions fairly scampered up the steps to see it.

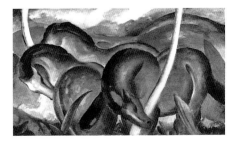

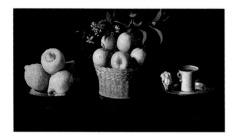

FRANCISCO DE ZURBARÁN
(Spanish, 1598–1664)
Still Life with Lemons,
Oranges and a Rose, 1633
Oil on canvas, 62.2 x 109.5 cm
(24½ x 43⅛ in.)
Pasadena, California,
Norton Simon Foundation,
F.1972.06.P

Museums are attracting larger audiences than ever before. Today, at a time when many institutions have undertaken ambitious construction projects, it may be the museum building itself that is the initial lure. In other cases, it is a touring show that is responsible for generating the long lines of enthusiastic timed-ticket holders that wend their way around the block. I have nothing against great architecture, and there is a lot to be said for "once-in-a-lifetime" experiences. Lately, however, I have found myself gravitating to the permanent collection galleries of the museums I visit regularly in and around Los Angeles, where I have lived for the past ten years, to enjoy the special pleasure of checking up on old friends. In many museums, particularly those where the permanent collection is not conceived as the main event, a visit to those galleries often affords the opportunity to study great works of art undisturbed by other viewers. A few weeks ago, I spent time at the Norton Simon Museum in Pasadena with the mystical Zurbarán still life that rightly deserves designation as one of the great treasures of the region. Meanwhile, at museums around the country, visitors were undoubtedly queuing up to jockey for position in front of lesser pictures in highly publicized blockbuster shows. More recently, I was at the Getty Museum, where the collection takes center stage, even as dazzling city views compete for attention. As usual, the galleries were swarming with visitors. Nonetheless, I was able to find a quiet spot on the settee across from one of my preferred destinations—Rubens's *The Entombment*—and I wondered yet again at the ability of the artist to capture grief in a few brushstrokes.

The potential power of a museum's permanent collection, especially for a local constituency, cannot be underestimated. The act of visiting and revisiting a particular work of art does more than make a viewer deeply familiar with its composition. It often leads to an emotional attachment to the museum in which the work is installed, and I personally find that it fosters the sense that I have a vested interest in that institution. Over time, it makes the museum *my* museum.

With the exhibition *Departures: 11 Artists at the Getty,* eleven outstanding Los Angeles artists have been invited to make the Getty their own. This is an especially appropriate moment in the institution's history to extend such an invitation. The J. Paul Getty Museum has had a significant public profile since 1974, when its collections were moved from Mr. Getty's ranch house to a handsome re-creation of an ancient Roman villa on his Malibu estate. The Getty's acquisition program expanded exponentially during the next two decades, but the Villa's confined spaces allowed for only a limited selection of the Museum's holdings to be shown and appreciated. That situation changed dramatically when the new Getty Center opened in Los Angeles in December 1997. Collections that had been packed into the Villa's close quarters, or shown only in part, now have breathing room in generously proportioned galleries, and, overall, a far greater percentage of the Museum's holdings are on view.

The eleven artists who were invited to participate in *Departures* responded enthusiastically to the notion of delving deeper into the Getty's collections than a casual visit ordinarily allows. Most chose to review literature on the collections and to make repeated visits to the Getty Center. They studied works in the galleries and in storage at both the Museum and the Getty Research Institute. Some artists met with members of the curatorial staff to glean more information about individual pieces. Finally, selecting items of particular interest to them as points of departure, the artists created works of their own.

Spanning a broad stylistic and emotional spectrum, the works produced for this exhibition reflect the unique and complex relationship that has always existed between artists and museums. Artists are simultaneously patrons of museums and creators of their contents. Museums are centers for inspiration,

intellectual stimulation, and ideas as well as repositories of their products. Colored by mutual dependencies, the relationship between individual and institution is often highly charged, and, not surprisingly, museums generate a wide range of responses among artists, from love, respect, and gratitude to distrust, contempt, and outright hatred. Indeed, the Getty's invitation to artists to use the collection as the source and focus for invention resulted in some genuinely warm embraces, a few pokes in the ribs, and a couple of seriocomic stabs in the back. Whatever their tenor, however, all the works in this exhibition honor the art-historical continuum: they acknowledge that every artist, no matter how radical and inventive his or her work may be, is in some manner tagged onto the end of one tradition or another.

As significant as this shared affirmation are the conspicuous differences in approach, perspective, and method to be found among the eleven participants in this exhibition. Responding to the diversity of expression in the Los Angeles art world today, I sought to bring together a wide range of individuals and practices. The result is an inescapably subjective sampling of some of the most talented artists currently living and working in the area. The aim was not to "cover all the bases" or to select artists to represent particular backgrounds, generations, schools, or tendencies. The artists represent, to put it simply, themselves.

Departures explores the potent and sometimes surprising ways in which the art of the past can inform contemporary art. The historical works that served as catalysts for the artists' new creations could hardly be more diverse, and, taken together, they form a selective guide to the strengths of the Getty's collections: classical antiquities, medieval and Renaissance manuscripts, European paintings and drawings, eighteenth-century French decorative arts, and nineteenth-century photographs. The presence of important contemporary works at the Getty Center is referenced in the artists' choices as well. Two artists, with virtually polar sensibilities, have tipped their hats to Robert Irwin's Central Garden, one of several works by distinguished living artists commissioned by the Getty Trust for key public spaces at the Center.

The new works that constitute the *Departures* exhibition are powerful expressions in and of themselves; each is a product of its maker's singular vision. Viewed with the knowledge of their ancestry, however, they accrue additional layers of meaning and affect. Windows onto the sensibilities of both their creators and their predecessors, they are also lenses through which we can examine the enigmatic nature of inspiration and the creative process. In the end, they remind us that the making of art and the experience of viewing art are inexorably bound to the idiosyncrasies of individual intelligence and perception.

The obligations that artists have to their forebears and the ways that the prior achievements of others are incorporated into works of art are not easily decipherable. Most educated viewers of art try to make such connections, always with qualified success. The mantle of history may be a heavy burden; it clearly rests more lightly on some shoulders than others. We can be grateful to the artists represented in this exhibition, for there is much to be learned from their efforts to come to terms with the past and to propel the force of their wisdom into the future.

Lisa Lyons
Guest Curator

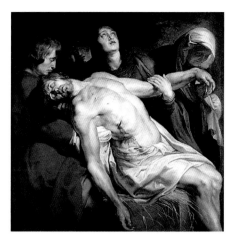

PETER PAUL RUBENS
(Flemish, 1577–1640)
The Entombment, ca. 1612
Oil on canvas, 131 x 130.2 cm
(51⅝ x 51¼ in.)
Los Angeles, J. Paul Getty
Museum, 93.PA.9

JOHN BALDESSARI

SPECIMEN (AFTER DÜRER)

August 24, 1999: I arrive home to find my fax machine printing out a newspaper article headlined "MEET THE BEETLE." It seems that a Japanese businessman has shelled out $90,000 for a bug. Stag beetles usually start at about $4.50 in Japan, where they are called "black diamonds," a reference to their shiny black exoskeletons. But the 3-inch specimen in question is considered unusually large, according to a pet-store spokesperson, who says that the beetle's buyer is refusing to be identified or interviewed for fear of being targeted by thieves. Bugs hold a special place in the hearts of many Japanese, who often keep crickets, beetles, and fireflies as pets, notes the article. Insect calls are considered soothing and remind the nature-loving Japanese of a simpler, less hectic age."[1]

The amusing article is a communiqué from John Baldessari, whose mind is very much on bugs these days, or, more accurately, on a particular bug: Albrecht Dürer's *Stag Beetle*. Baldessari has selected this drawing, among the most famous animal studies of the early German Renaissance, as the starting point for his *Departures* project.

Several weeks previously, I had joined Baldessari in the Getty storerooms to examine the Dürer drawing, which is sensitive to light and cannot be exhibited for long periods. It is one of those pieces that, if known only in reproduction, tends to startle when seen in person. Displayed in the viewing room on a tabletop easel, unprotected by glass, the diminutive work is an astonishing presence.

In his drawing, Dürer presents the stag beetle illusionistically, as an animate being casting its own shadow on the mottled paper, as if it were actually creeping across the page. The subtle gradations of smoky hues that run from the creature's gigantic mandibles, along its massive head, and across its articulated wing covers are painstakingly rendered. "That Dürer could have that kind of alertness," Baldessari says, "that he could record that much information, I find amazing." His sentiments underscore the observations made in the Museum's catalogue entry on the piece: "Conceptually, the drawing combines the notion of representation with one of intellectual illusion, looking back to anecdotes about Giotto and ancient painters composing deceptively real insects, and

ahead to the scientific naturalism of the future. It is for this reason that the drawing had so great an influence in its century and has proven so affecting throughout its history."[2]

It seems appropriate that Baldessari should have chosen to focus on such an influential work, for in a career as an artist and teacher that spans more than thirty years, he has had a powerful impact on the character of contemporary art. Since helping to sow the seeds of Conceptualism in the 1960s, he has produced an impressive body of rigorously intellectual, often patently humorous work in a range of diverse media. He has used painting, drawing, prints, photography, video, film, installations, and exotic combinations of these to produce art that challenges the conventions and pushes at perceived boundaries of art-making. And, in his uncanny ability to create lyrical works from appropriated images and texts, he has inspired succeeding generations of artists to mine the mass media for the stuff of their creations.

It was a reproduction that first piqued Baldessari's interest in the Dürer drawing in the winter of 1999. Studying a handbook of the Getty Museum's collection, he was immediately attracted to using the *Stag Beetle* in this project, but he has a tendency to be suspicious of initial impulses and he set the idea aside. He was still under the sway of another master, having recently completed a series of works that incorporate details from prints, drawings, and paintings by the innovative Spanish artist Francisco José de Goya y Lucientes (1746–1828). Later that season, Baldessari traveled to Vienna, where the Albertina Museum mounted an exhibition of his Goya series alongside selections from the museum's extensive holdings of the Spaniard's work. He passed an afternoon in the Albertina's vaults, poring over drawings from the institution's renowned collection, among them a large number of works by Dürer, whose abilities as a draftsman he describes as "staggering." With that experience in mind, he decided that his instincts to capture the Getty's bug for his own use were correct.

"One of the goals of a contemporary artist should be to keep art alive," he said during a recent conversation in his studio. "Art shouldn't stagnate, it shouldn't die, but a masterpiece is only a masterpiece insofar as it informs the present." This point of view sheds light on his strategy: working from a transparency of the $5\frac{9}{16}$-by-$4\frac{1}{2}$-inch drawing, he intends to create a $14\frac{1}{2}$-by-$11\frac{1}{2}$-foot ink-jet enlargement of the image on canvas mounted on a rigid panel. Blowing the diminutive

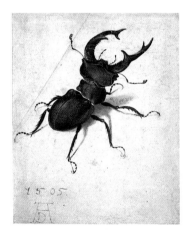

ALBRECHT DÜRER
Stag Beetle, 1505
Watercolor and gouache
JPGM, 83.GC.214

picture up to colossal scale is a way, Baldessari explains, of "putting a loupe on it for the viewer, of saying, 'pay attention, this is important.' It is a 'hyper' way of doing what the museum does in a more genteel fashion."

The work will be mounted with a single metal specimen pin fabricated in relative scale to the gigantic insect. Stabbed through the back of the stag beetle, the pin will add a layer of *trompe l'oeil* illusionism to the illusionistically rendered critter, appearing to have put an end to his trek across the paper. *Specimen (After Dürer)* will not hang plumb and true, but askew; its position will be determined largely by gravity. Chance, Baldessari notes, has always been an important factor in his work, and he is not aiming to place his big bug at a purposely artful angle. He reaches for his ingeniously simple preliminary study for the monumental work: a postcard of the *Stag Beetle*, pierced by a T-pin. "I will accept anything, and that's a strategy that I have used for some time," he observes, as he holds the metal lance and watches where the card comes to rest. "That's also about examining every convention for art and questioning whether one has to accept it as a given. Is there a reason why art has to be level on the wall?" He pauses and then, by way of further explanation, adds, "If you are putting all your waking hours into doing art every day . . . you are getting pretty good at having a kind of rarefied taste. So, metaphorically, you are eating some two-hundred-year-old gorgonzola cheese while the rest of the world is eating mild cheddar. Sometimes it's just nice to escape your own well-developed taste and see what happens if you leave things to chance. It's a Cage-ian, Duchampian idea, but it's a very good one."

Of course, by hanging the work in a highly unconventional manner, Baldessari is also taking a poke at standard museum installation practices, at keen-eyed curators supported by legions of art handlers armed with spirit levels. In addition, he admits that he is "in some mildly aggressive way . . . addressing the viewer, who might feel himself attacked." He conjures a Kafkaesque vision: "Perhaps you can project into the position of the bug and imagine yourself in some other world, being pinned to the wall as a specimen." Baldessari laughs when I point out that, in a sense, that's precisely the situation in which the *Departures* exhibition places him. By agreeing to create a piece based on a work in the Getty's collection, he is, figuratively speaking, pinning himself to the museum wall.

Categorizing *Specimen (After Dürer)* is as difficult, to use one of Baldessari's favorite turns of phrase, "as trying to nail Jell-O to a wall." In its combination of media, the work is a slippery hybrid, but Baldessari prefers to describe it as sculpture. "If something is conventionally hung on a museum wall, it becomes invisible as an object—just like the way we look at TV, and we don't think it's a box, but it is a box. Looking at paintings, we don't see the stretcher bars, we just see an image. With my work for the Getty, where it's huge and it's pinned to the wall, its objecthood becomes really apparent. And once you say object, it's a hop, skip, and a jump to sculpture."

Contemplating how Dürer's beetle, vastly magnified by Baldessari's intervention, will look in the Getty's gallery, I detect a whiff of the irrational. A host of associations are called forth: the surrealist visions of René Magritte (think of his giant apple that fills an entire room); the writings of William S. Burroughs; and the monster-bug subgenre of sci-fi horror cinema—*Arachnophobia, The Fly, Attack of the Giant Leeches*. For his part, Baldessari, the master of the visual double entendre, is looking forward to the witticisms *Specimen* is sure to spawn. The fabricators who are working with him on the piece have already gotten the ball rolling on a millennial theme. They refer to Baldessari's work as "The Y2K Bug."

13

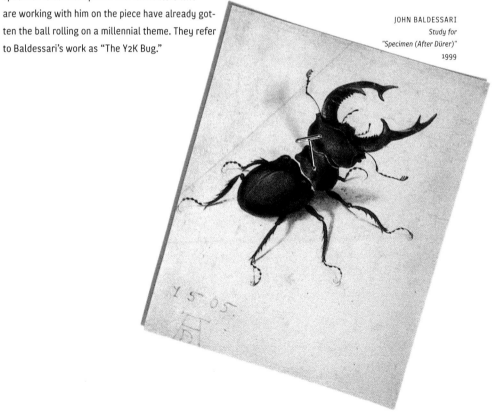

JOHN BALDESSARI
*Study for
"Specimen (After Dürer)"*
1999

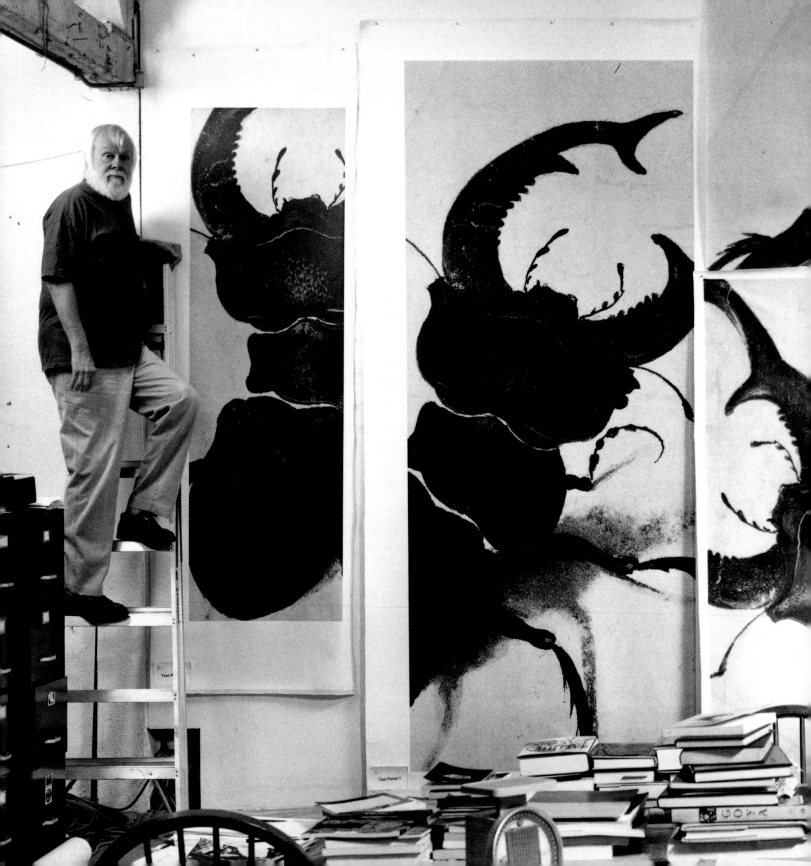

UTA BARTH

...AND OF TIME.

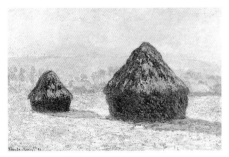

CLAUDE MONET
Wheatstacks,
Snow Effect, Morning, 1891
Oil on canvas
JPGM, 95.PA.63

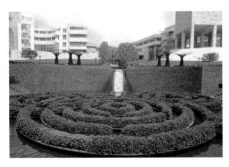

ROBERT IRWIN
Central Garden, 1997
Getty Center

When I visited Uta Barth in her Santa Monica studio in October 1999, she was reviewing the results of her recent labors. Pinned to the walls were dozens of white cards, each bearing contact prints of color photographs. Just a fraction of the hundreds of pictures that Barth had shot in her nearby home over the past six months, these were the preliminary studies from which she planned to create her *Departures* project: a series of four or five large-scale diptychs and triptychs comprising framed color photographs, accompanied by a thirty-two-page book that will serve as a selective visual index to the entire body of images.

From a distance, the roughly 2-inch-high rectangles of visual information, mounted singly and in pairs, suggest a wordless storyboard for a film. Closer examination reveals that each print contains an unprepossessing view of a sparsely furnished living room. The pictures are in no sense formal studies of the interior's architecture or its contents, and even by examining all the prints one doesn't gain a clear understanding of the layout of the entire space. Instead, they offer only cropped glimpses of parts of the room, photographed at medium to relatively close range. The top of the back cushions of an ochre couch that lines one wall is featured in several pictures, as is an expanse of beige carpeting with a slice of the underlying wood floor. A section of a white wall with a George Nelson bubble lamp hanging over a pair of director's chairs appears in a handful of pictures. A few inches of the lower panes of a bank of windows and the side of an adjacent armchair show up in many others.

The pictures are handsome, but there is nothing especially dramatic about any one of the images. At first blush, they all have a certain informal, snapshot-like quality, as if they were taken "on the fly" with little thought given to framing or composition. But the sheer number of images on Barth's studio walls and the obviously careful pairing of closely related, and sometimes virtually identical, views suggests that there is nothing casual about the artist's undertaking. Studying the entire group, one begins to comprehend that the pictures record something more than furnishings and fixtures, something far more elusive and fleeting. It is the light that streams through the windows and plays across the surfaces of the

room that appears to be the focus of Barth's enterprise.

And yet, as one continues to examine the photographs, one realizes that they are not concerned strictly with exploring the patterns of window mullions cast against the floor and the delicate effects of reflected light washing across the walls. Barth uses light not as a subject in and of itself, but as a vehicle to focus one's attention on even more intangible things—on issues of time and perception. As I scanned the images on the studio walls, I recognized the subtly subversive powers of her pictures. They had slowly and quietly stolen into my brain under false pretenses—"*Here, have a look at the couch and watch the way the light dances across the room*"—only to unlock the vaults of my senses. As a viewer, I had begun to participate in the process that led the artist to record the views. I was engaged not so much in looking *at* something as in the act of looking itself.

At this writing, Barth has chosen . . . *and of time.* as the working title for her *Departures* project. The enigmatic sentence fragment suggests the temporal nature of the glancing visions presented in the individual photographs and underscores that surface reality is only part of what the pictures explore *in toto*. In its emphasis on time, the working title also offers a clue to the two departure points Barth selected at the Getty. The first of these is *Wheatstacks, Snow Effect, Morning*, one of the earliest paintings in the first serial body of work undertaken by the great French Impressionist Claude Monet. Beginning in the fall of 1890, Monet produced thirty canvases that captured what he called his "experience" of the wheatstacks located in a field just outside his garden at Giverny as they were altered over time by nature's interventions. As noted in the Museum's handbook, the painting in the Getty collection is a "quintessential Impressionist work" whose "densely worked, complex surface reveals Monet's long, intense efforts in the studio striving to capture a precise, evanescent moment."[1]

Barth says that she has "never been a Monet fan," but she is interested in the fact that he chose "to spend many months of his life looking at the same thing continuously—not really looking at the subject, but looking at the conditions of the subject." Indeed, her observation is echoed in the Impressionist's own words. Monet said: "For me a landscape hardly exists at all as a landscape, because its appearance is constantly changing; but it lives by virtue of

its surroundings—the air and the light—which vary continually."[2] Barth is dismayed that the Getty owns only one example from the *Wheatstacks* series. As she explains, "The content of that work—which is about watching light—doesn't reside in a single piece. What is important and interesting to me is that Monet made the entire series, which is where the content resides. That content disappears when you see only one canvas."

Ultimately of greater significance to Barth than Monet's painting is the departure point that she found for her project in the Getty's Central Garden, created by the pioneering "light and space" artist Robert Irwin. The first in a series of major works by contemporary artists commissioned by the Getty Trust for public spaces at the Center, the fantastic environmental folly contains, among other features: an allée of London plane trees; stone pathways lined with Cor-ten steel walls; wooden benches and bridges; steel bowers brimming with bougainvillea; a rock-strewn stream leading to a waterfall above a pool on which a maze of azaleas appears to float; terraced beds holding more than five hundred varieties of plants; and rows of crape myrtle trees. Irwin's garden is a study in both moment-to-moment and more gradual, seasonal transformations, and, like Monet's *Wheatstacks*, it celebrates the ephemeral qualities of natural phenomena.

Within Irwin's complex garden, Barth focused on one small detail. Set into the ground at the center of a footpath is a stone slab engraved with the following inscription:

EVER	EVER
PRESENT	CHANGING
NEVER	NEVER
TWICE	LESS
THE	THAN
SAME	WHOLE

Irwin's poetic motto has become a touchstone for Barth, who has long admired her Southern California colleague for "his investment in sight and perception." In Barth's view, the side-by-side columns of twelve simple words constitute an elegant "structure for thinking about looking and repetition." As such, they capture the spirit of her *Departures* project, which, like many of Irwin's creations, emphasizes the primacy of sensory experience over conventional forms of subject matter.

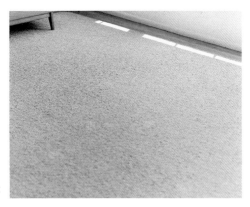 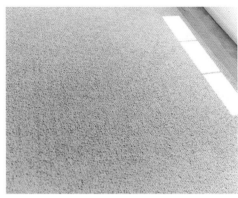

UTA BARTH
Color photographs
from the series
. . . and of time., 2000

Indeed, in planning her photographs for the *Departures* exhibition, Barth employed several strategies, beginning with the selection of their locale, to dislodge the viewer's attention from the ostensible subjects of the pictures. She briefly considered photographing in "some banal location in Los Angeles," but soon concluded that "no matter where I went in town, I would be choosing something." Training her lens on her living room to photograph the things that are around her all the time, she says, ". . . is like choosing nothing." The living room was likewise her "non-choice" of venue for *nowhere near*, a recently completed body of work for which she spent six months pointing her camera at a bank of windows and recording hundreds of views on both sides of the panes. As in that project, Barth's current work involves using repetition as means of focusing attention on perception and duration. "You don't need fifty pictures of my couch to think about the couch," Barth notes. "So the question arises: Why are there fifty of them? You begin to wonder if the pictures are really about that couch or whether they are about an individual's engagement in the act of looking over time."

The temporal aspect of Barth's undertaking is reinforced by the sequencing and seemingly casual framing of the views, which suggest the act of glancing at or seeing something in passing. Some of the paired pictures were shot only five or ten minutes apart, while others are separated by three or four hours. But, no matter what duration they span, the images invite one to enter a contemplative psychological space where one can be fully present in the current moment, suspended in the activity of looking. As Barth so eloquently describes it, her works offer the viewer "the visual equivalent of silence."

following pages: Uta Barth, November 12, 1999

SHARON ELLIS

A VISION OF
SPRING IN WINTER

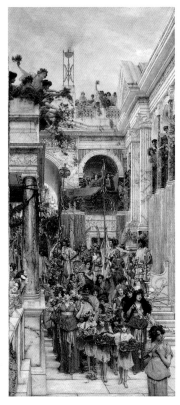

LAWRENCE ALMA-TADEMA
Spring, 1894
Oil on canvas
JPGM, 72.PA.3

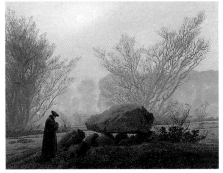

CASPAR DAVID FRIEDRICH
A Walk at Dusk, ca. 1830–35
Oil on canvas
JPGM, 93.PA.14

A Vision of Spring in Winter is the latest in the ongoing series of luminous paintings of imagined views of nature that has occupied Sharon Ellis for the past decade. It is also her largest work in some time. Hardly a big painting by conventional standards, the 4-by-5-foot composition nonetheless represents a major undertaking for the artist, a methodical worker who is devoting the better part of a year to its creation. She spent almost two months engaged in preliminary research and a month drafting her initial working drawings before setting brush to canvas. At this writing, Ellis is slightly more than halfway through the painstaking, seven-month process of building the image from layer upon layer of thin, alkyd paint. Judging by the results of her labors to date, it is time well spent.

The painting depicts a landscape rendered with the intensity of a vision seen in a dream or hallucination. The view of a vast, rolling terrain with outcroppings of dun-colored rocks spreads across the canvas, framed at either side by the black trunks and bare, gnarled branches of two enormous trees. The upper half of the painting is all sky. Its bright blue expanse is interrupted by an eerie-looking cloud bank with hydra-like tentacles illuminated from behind by cold, white light that gives the scene a wintry appearance. Deep in the center distance, another towering pair of black trees is silhouetted against the sky. Their crabbed, leafless limbs seem charred by fire. The brooding mood that pervades the painting is mitigated by a magical spectacle taking place in the foreground. Here, dozens of bright spring flowers appear not so much to grow from as to levitate above a verdant lawn, while translucent-white, star-shaped blossoms flutter like snowflakes from the sky.

In both style and content, Ellis's captivating painting-in-progress reflects her fondness for nineteenth-century art and poetry. And, as analysis of the composition reveals, she has drawn inspiration and details from three works of the period in the Getty Museum's collections: Sir Lawrence Alma-Tadema's painting *Spring*; Caspar David Friedrich's painting *A Walk at Dusk*; and *Oak Tree in Winter*, a photograph by William Henry Fox Talbot. Yet Ellis is not engaged in fabricating a simple-minded pastiche; rather, through her own highly imaginative transformations, she is synthesizing her sources to create a

thoroughly unique and personal conception of nature and its intrinsic beauty.

Ellis's trio of departure points in the Getty's collections form a thought-provoking visual essay on diverse nineteenth-century sensibilities. Alma-Tadema's meticulously painted, idealized vision of a joyous, flower-strewn Roman festival embodies the late-Victorian obsession with all things antique. Friedrich's pensive landscape, by contrast, with its implicit message of death conveyed by a figure contemplating a pre-historic tomb, is a prime example of the German Romantic movement's embrace of sober Christian themes. Talbot's striking photographic portrait of a barren tree suggests the equal measure of reverence for the wonders of scientific invention and the splendors of nature that shaped the thinking of many early practitioners of the medium.

As a self-described connoisseur of beautiful trees, Ellis's appreciation of the magnificent specimen in Talbot's photograph is easy to understand. When asked to explain her attraction to two paintings as widely divergent in aesthetic as the Alma-Tadema and Friedrich works, Ellis replies, "Well, to put it simply, they are both really good pictures. And, no matter what else you are doing as a painter, in the end you are always trying to make a good picture. You want the composition to be good, you want the meaning, the color, the line, the subject matter all to work together and make the painting exist as a perfect object that communicates. And, from that standpoint, *Spring* and *A Walk at Dusk* are really good pictures."

Both paintings, Ellis adds, "have a claim on naturalism, on realism, but they are, in fact, fantasies," and each portrays an invented scene incorporating elements of things observed. Although the edifice in Alma-Tadema's depiction of the Roman festival of Cerealia is largely a product of the artist's imagination, it includes portions of actual buildings, and its inscriptions and reliefs can be traced to the photographs of antique sources that the painter collected in great number. Likewise, the megalithic tomb is a motif that appears frequently in Friedrich's work, and the particular configuration of rocks pictured in *A Walk at Dusk* was placed by the artist in another setting in one of his earlier paintings.[1] Thus, the moonlit landscape with its solitary figure—perhaps a portrait of Friedrich himself—seems more a depiction of a contemplative state of mind, of an inner vision, than of external reality. "In a sense," notes Ellis, "both artists portray a

desire for escape, for transcendence. Alma-Tadema seeks to escape to a better time, and Friedrich, turning to God, seeks a better place, beyond the physical world."

Approaching her project for the *Departures* exhibition, Ellis initially thought to make two small paintings, one inspired by the Friedrich and another by the Alma-Tadema. In studying the latter, she learned that its artist-designed gilt frame is inscribed with four lines from *Dedication*, a poem by Algernon Charles Swinburne (1837–1909). Although he fell out of favor in the twentieth century, the late-Victorian poet is admired by Ellis. After a visit to the Museum one day, she took an old edition of Victorian poetry from her studio bookshelf. Leafing through the volume in search of *Dedication*, she came across another Swinburne poem, *A Vision of Spring in Winter*.[2] Written in 1878, the melancholy meditation on the poet's favorite season expresses his sorrow over the loss of times past and his yearning for the future. Its verses appealed to Ellis, who found in them, she says, "a perfect synthesis of the imagery and mood" of the two paintings at the Getty that had piqued her interest. Rather than a pair of small works, she immediately began to contemplate a single canvas, large enough to accommodate her expanded vision of a panoramic landscape embodying the combined themes of loss and renewal inspired by her nineteenth-century predecessors.

The new painting marks a change not only in scale but in compositional format for Ellis, whose preferred canvas in recent years has been a 40-by-30-inch vertical. In her stunning series of six paintings, *Times of the Day*, 1998–99, inspired by the drawings of the nineteenth-century German painter Philip Otto Runge, Ellis capitalized on the format to record the effects of light on intimate details of otherworldly landscapes viewed at close range. The space depicted in these pictures is extremely shallow, with the images pressed up against the canvas surface. In *A Vision of Spring in Winter*, by contrast, the landscape unfolds horizontally and ranges deep into the distance. Meanwhile, the delicate flowers in the foreground—based on Ellis's own photographs of blooms in Robert Irwin's Central Garden at the Getty Center—seem to hover in front of the picture plane, piling another layer of three-dimensional illusionism onto the scene.

Ellis based the sentinel-like trees that bracket the view, and hold the image in check, on the mighty oak recorded in Talbot's photograph. To capture its complex branch structure,

she used the familiar technique devised by Renaissance masters and adapted by contemporary billboard painters. She began by overlaying a black-and-white glossy reproduction of Talbot's picture with a grid, then, unit by unit, transferred the image in pencil at larger scale onto a sheet of tracing paper. Next she "flopped" the drawn image to reverse its orientation and divided it vertically, using each resulting half to create templates for two new trees, which she deployed symmetrically on either side of her painting. The pair of trees at the center of the composition required considerably less engineering. They are relatively straightforward iterations in paint of trees photographed by Ellis in Southern California's Joshua Tree National Park.

Sitting in her studio recently, looking at the painting on her easel, Ellis provided color commentary on what she described as "the battle between Spring and Winter" that was being played out on the canvas. "In my mind, Spring was to be ethereal, but I didn't like the way that Winter was predominating, and so Spring is taking over." The dark, somewhat foreboding passages of the picture "had begun to make the painting look too dead," she observed, and had put her in a funk for a while. In retaliation, she had begun pumping up the intensity of the blossoms in the foreground, whose initially wan tones were inspired in part by Swinburne's description of "ghostly growths of flowers." The once pale-violet blooms were now deep magenta, and the previously light-saffron daisies had been made vibrant yellow. Earlier in the week, Ellis had begun adding licks of crimson hues to the peach poppies, whose beautifully rendered, translucent petals are a testament to her astonishing technical facility. She speculated that these adjustments to the smallest details of the painting will force larger changes in the composition down the road. The war of the seasons is far from over.

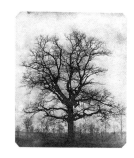

WILLIAM HENRY FOX TALBOT
Oak Tree in Winter, 1841
Salt print
JPGM, 84.XM.893.1

SHARON ELLIS
A Vision of Spring in Winter,
in progress, November 1999

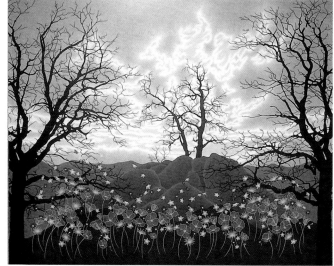

following pages: Sharon Ellis, November 5, 1999

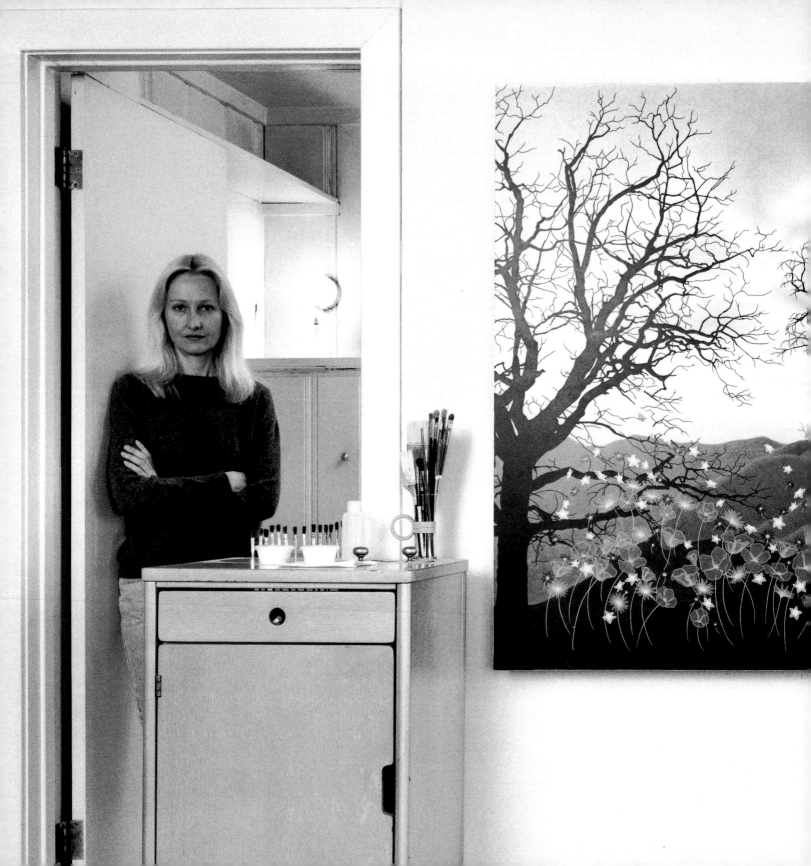

JUDY FISKIN

MY GETTY CENTER

Getty Center
Aerial view looking south

Régence Paneled Room
(1670–1720)
A Getty Museum gallery that
appears in Judy Fiskin's video
My Getty Center, 2000

On February 5, 1998, Judy Fiskin stepped out on her back porch and switched on her video camera. The image in the viewfinder of rain falling on the shrubs was hardly extraordinary, but the precipitation was far more significant than appearances would suggest. It was the first of the long-anticipated storms associated with El Niño, the most widely publicized weather event of the decade.

Fiskin wasn't certain what she would do with the backyard footage, but that didn't bother her. Since the fall of 1997, she had been shooting a number of sights that were interesting to her in one way or another, and for which she had no specific purpose in mind. During the next year and a half, she continued to shoot in this essentially undirected manner. She videotaped county fairs and sidewalk art festivals, and she roamed Los Angeles neighborhoods in her car, using a super-8 camera to record a variety of scenes that appealed to her idiosyncratic eye.

Early in the winter of 1998, Fiskin paid a visit to the Getty Center. Like the much-ballyhooed arrival of the El Niño storms, the recent opening of the Center's new facilities had received extensive advance press in Los Angeles. Fiskin admits to having been annoyed by the avalanche of media attention the two unrelated events generated, and she was vexed by the hundreds of banners that peppered the city proclaiming "Your Getty Center." A skeptic by nature, she was as dubious about the accuracy of the advertising slogan as she was about the weather reports. Whose Getty Center would it ultimately be? Would it belong to the local populace or would legions of "invaders" seize the hilltop complex? According to newscasters, out-of-town tourists were snapping up parking reservations in startling numbers. At some point, Fiskin says, "the hype about the Getty and the hype about El Niño" converged in her brain. Scenes she had shot previously without clear intention began making sense to her, and a script for a video started to take shape. Its title came in a flash: *My Getty Center*.

A critically acclaimed, twenty-five-year veteran of still photography, Fiskin switched to video, with intermittent forays into super-8 film, in 1995. She began by making a short tape in memory of her late father, which she considers "too awkward, raw, and personal" to be shown publicly. Her sec-

ond effort in the medium, *Diary of a Midlife Crisis*, 1998, chronicles her attempts to learn to use a video camera while meditating on art, aging, and creativity.

With *My Getty Center*, her elegantly constructed, pseudo-documentary–*cum*–fable about the harmonic convergence of what she refers to as "two cataclysmic events," Fiskin has fully come of age as a video artist. Narrated by Fiskin in the calm, voice-of-reason tones of a public-radio host, the sixteen-minute tape conveys the artist's ambivalent attitudes about museums in general and the Getty in particular while providing rueful commentary on the fate of a society that appears to be losing its aesthetic compass.

The video's story line about the concurrent arrival of El Niño and the Getty Center unfolds in sequences of original footage shot by Fiskin deftly interwoven with material appropriated from broadcast TV, old movie-house newsreels, and low-budget documentaries on obscure subjects. Fiskin also incorporated several segments from *Concert of Wills*, a film commissioned by the Getty that traces the fourteen-year design-and-construction process of the Getty Center.[1] The juxtaposition of *Concert*'s slick, high-production values with Fiskin's infinitely more homespun footage provides some of the wittiest moments on the tape. Over gorgeous panoramas of the Center under construction (in scenes borrowed from the Getty film), Fiskin narrates: "In the meantime, while we were at the bottom of the hill worrying, up at the Getty they were building. . . . Building was so much in the air, it was contagious. I wanted to build something, too. I decided to make a rubber-band ball." The screen begins to flash with a herky-jerky, time-lapse sequence of a rubber-band ball growing in circumference, while the words "September, October, November" pop into the frame at intervals to document the passing months. (In actuality, Fiskin spent just a few days on the project.)

The lowly rubber-band ball recalls Fiskin's photographs of the early 1980s, in which she documented artifacts of popular culture that both repelled and attracted her, including tacky floral arrangements and craft projects by weekend hobbyists. The beautifully composed pictures of guilty pleasures raise interesting questions about how aesthetic judgments are made. In *My Getty Center*, Fiskin probes these issues further, using a dream sequence to comment on the inflated rhetoric that surrounds both the sublime and the ridiculous:

I dreamed that it rained so hard that the River of

High Art and the River of Low Art both overflowed their banks, and, as they flowed to the sea, their contents intermingled. Bulldozers were working frantically to sort the high art from the low art, but it was too late. No one could tell them apart anymore. . . . Soon art was everywhere. By the old standards, the results were mixed, but the old standards no longer applied. When word got out about this situation, more tourists than ever before came to L.A. The local economy flourished.[2]

Throughout the video, Fiskin casts her gimlet eye in contrary directions. Exiting the Getty tram, she aims her camera not at the imposing structures around her, nor at the grand vistas from the Center's mountain perch, but directly down at the travertine plaza floor. Arriving at the Museum, she turns away from its inviting entrance to a long wall of white metal tiles. After being interrupted by an impromptu lecture by a docent about the 30-inch module that is the basis of the Richard Meier–designed complex, she walks toward the wall until the module dissolves into a sea of white nothingness. The moment affords Fiskin the opportunity for a meditation on modernism:

> And I understood some other things, too. I knew that the docent's white square was the essence of modernism and that it expressed all of modernism's passionate attachments—its will to order, its devotion to purity, and, most of all, its longing . . . for oblivion. . . . On the other hand, our desire for nothingness is matched by an equally strong desire to fill things up.

What we most want to use to fill things up, Fiskin's video seems to suggest, is talk, and lots of it. In the tape, we see few people, but we hear many voices, including rafts of reporters who blather endlessly about El Niño. At one point, we eavesdrop on a docent talking with a group of kids. The camera holds steady on a sumptuous Carlevarijs painting of the annual celebration of the marriage of Venice to the sea. Meanwhile, the tour guide asks her young charges whether Venice, whose sun-drenched stone facades here bring to mind the Getty's travertine ramparts, looks like a rich city or a poor city. "RICH!" chime out the eager children. Following the segment, Fiskin says nothing, but her camera speaks volumes. She trains her lens on an elevator as its vaultlike doors slam

shut, as if to register her displeasure with the speaker's decision to focus on finance at the expense of aesthetics.

All talk stops when Fiskin walks through the Museum's galleries to survey the art. We hear only the sound of squeaky shoes treading the wood floors as the camera slowly wanders the rooms, lavishing attention on the beautifully installed collections. The contemplative journey ends with a *tour de force* montage of exquisitely framed portraits of antique, Renaissance, Baroque, and Neoclassical sculptures. With this visual love poem to art at its most elevated and elevating, Fiskin stakes her claim to the Museum. Here, in the galleries, the Getty Center is indeed hers.

But not for long. In the end, Fiskin's ambivalence gets the better of her, and she dreams up a flood of biblical proportions to remove the thorn in her side:

> A torrent of water covered the San Diego Freeway and rose to the top of the Getty hill. The Museum floated off its foundation and—filled with tourists, guards, and the bastard arts—it sailed off to Hawaii. Witnesses reported that they heard the sounds of Polynesian music coming from the complex as it disappeared over the horizon. . . . Afterwards, there was just one wall left on the hill. It became a famous relic of modernism and a melancholy tourist destination—our Acropolis.

The camera zooms in to watch as an accordionist seated before a white tile wall plays a wistful Russian folk song. You begin to get the feeling that Fiskin is genuinely sad to send the Museum packing, that she regrets her "my way or the highway" (make that "high seas") attitude about the Getty Center. But then, it's just a dream. The video ends on a celebratory note with picture-postcard views of the Getty, ostensibly on its new South Pacific beachhead, accompanied by that classic Hawaiian party anthem, "Hukilau." You can almost hear Fiskin singing along. Pupu platter, anyone?

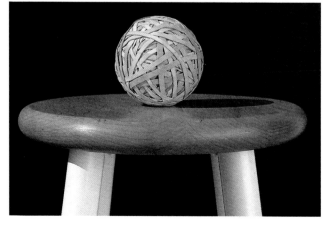

Rubber-band ball created by Judy Fiskin for *My Getty Center*, 2000

MARTIN KERSELS

KOUROS AND ME

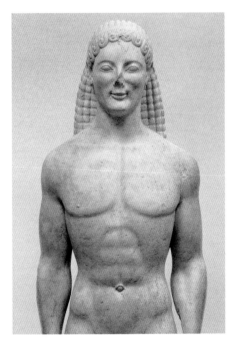

Getty Kouros (young man)
Greek, ca. 530 B.C. or
modern forgery
JPGM, 85.AA.40

Discussing Martin Kersels's art is like giving someone directions on how to navigate a field mined with alternating rows of explosive devices and whoopee cushions. If you expound on his work in strictly serious tones, you risk sounding ridiculous, and if you submit to the temptation to focus only on the humor that infects his creations, you give short shrift to other important qualities that lend his work its gravity. Kersels himself admits that his art is something of a booby trap. Asked what he hopes people will take away from his work, he replied, "I guess my ideal viewer . . . would laugh heartily, and then upon walking away, would cry."[1]

A Los Angeles native, Kersels studied art at UCLA, receiving his BFA there in 1984 and his MFA in 1995. As an undergraduate, he was especially influenced by the artists Chris Burden and Yves Klein: "I liked [Burden's] focus on taking a simple—if transgressive or startling—idea and finding a straightforward technical means to achieve it. . . . In Klein's work, his raillery and showmanship—and awareness of the audience—made me realize that humor did have a seat at the table of big ideas."[2] He also cites as early role models "musicians like Elvis Costello, for his wordplay; writers like Raymond Chandler, for his snappy hard-boiled descriptive prose style and his use of the theme of the errant knight; and filmmakers such as Alfred Hitchcock, Wim Wenders, and Buster Keaton, for their sense of timing and imagery."[3]

Kersels began his career as a performance artist, working solo as well as with the collaborative SHRIMPS, which staged humorous pieces involving elements of dance, theater, opera, and slapstick comedy. He later applied the tools that he acquired as a performer—lessons in movement, timing, audio, and staging—to the creation of sculptures incorporating motion, sound, film, and video. He calls these "performative objects." Bizarre, inspired, and infused with tragi-comic theatricality, these controlled-mayhem contraptions reflect the artist's love of technology, particularly in its older forms. In *Twist*, 1993, for example, an electric motor slowly winds a tangled rope made of more than ten thousand rubber bands attached to a prosthetic leg, until the tension causes the leg to start furiously kicking the wall. Then there's *Piano Drag*, 1995, in which a baby grand piano slowly winches itself across the gallery floor, and *Attempt to Raise the Temperature of a Container of Water by Yelling at It*, 1995, in which a disembodied voice emanating from a submerged speaker fruitlessly tries to do just what the title says. There is something silly, sinister, and yet thoroughly transcendent about these oddly anthropomorphic works, which set off an internal dialogue about the human condition that lasts long after you first encounter them. Imagine: Rube Goldberg meets Sisyphus, Cervantes, and the members of Monty Python for coffee as day breaks after a dark night of the soul.

The physicality that is such an important aspect of Kersels's sculptures also informs his video, film, and photographic works, which typically feature the artist as performer. At 6 feet 6 inches and roughly 350 pounds, Kersels is an imposing presence, and he capitalizes on both his size and elements of slapstick comedy to tap into a deep well of pictorial invention. To produce the 1996 photo series *Tossing a Friend*, Kersels hurled several of his trusting pals, like human medicine balls, through the air. Contemplating the pictures, you can get so lost in the delirium of the moment that you may forget to think about the moment not captured—the landing. (No bones were broken; the subjects were pitched onto a foam pad borrowed from the UCLA athletic department.)

More recently, in the *Whirling Photos* series, 1999, Kersels hoisted friends by their ankles and spun them around. Meanwhile, the spinning friend, armed with an auto-focused, motor-driven Nikon, snapped pictures of the artist in midwhirl. Resembling pictures taken from a carousel, the resulting shots show Kersels within a cinematic maelstrom of blurred streaks of color. If the *Whirling Photos* are filmic, they are also mythic images, suggesting that the artist is not simply endowed with Herculean strength but is actually the power at the center of the universe, a titanic force that makes the world turn, the axis around which everything and everybody revolves.

For his *Departures* project, Kersels has once again decided to place himself squarely at the center of his art, but this time, he will be joined not by a friend, but by a sculpture: the Getty Kouros. This much-debated work is arguably the Museum's most troublesome acquisition. After more than fifteen years of study, scholars are still uncertain whether the piece is a genuine ancient Greek sculpture of about 530 B.C. or a modern forgery. Two years of investigation conducted

before the Kouros was bought in 1985 determined that the stylistic and scientific evidence pointed, on the whole, toward its being authentic, but in 1990 suspicions were aroused after a fake with similarities to the Kouros surfaced, and technical analysis was renewed. The Kouros was the subject of an inconclusive international symposium in Athens that the Getty helped to organize in 1992, and later it returned to exhibition at the Museum along with comparative materials and documentation. No new information has since been brought forth to argue against the Kouros; in fact, the weight of evidence supports its authenticity.[4]

Kersels went to the Getty Center on a scouting mission for the *Departures* project in the spring of 1999. He began by visiting the Museum's decorative arts and paintings galleries before moving on to the West Pavilion, where a selection of Greek and Roman works were on view. The Kouros was not among them. It was in storage, along with a majority of the antiquities collection, awaiting the completion of an extensive renovation of the Getty Villa in 2002.

As Kersels perused the gallery, his thoughts drifted to the absent Kouros. "The Kouros doesn't even have to be on display to have a presence at the Getty, because of the mystery and controversy that surrounds it," he notes. He admits to a certain perverse fascination with the fact that "despite all the energy that has gone into this one inert object" there may never be a definitive answer about its authenticity. "The Museum is an institution that is supposed to be founded on surety," Kersels observes, "but with the Kouros there is an admitted lack of surety. I like that unsteady ground." Moreover, the concept of the Kouros as a representation of the ideal male had been in the back of his mind ever since Kersels took a Greek art class as an undergraduate. "That ties in," he notes, "to my thoughts about my own body not being ideal by today's standards, nor by Greek standards, nor by any other standards for that matter."

Kersels let these ideas percolate; ultimately, he decided to produce a series of stop-action photographs of himself engaged in a variety of intensely physical actions with the Kouros. Of course, the actual sculpture could not be used in these tableaux, so he commissioned fellow Los Angeles artists Jared Pankin and Kelly McLane to produce a full-scale facsimile of the figure, carved from lightweight, high-density foam.

At this writing, the Kouros clone is being carved, and Kersels is busy plotting his plans and scouting locations for a series of four 4-by-5-foot color photographs. For one shot, he envisions using a trampoline to propel himself and his inanimate costar through the air from "stage left to stage right." Mary Collins, Kersels's wife, will take the photograph that will record, the artist hopes, the moment at which the larger-than-life pair crash headlong into a bush, their craniums completely buried in foliage and their bodies thrusting out into space as parallel to the ground as possible. Other scenarios under consideration include plunging over a sand dune in Death Valley, tumbling down a narrow, wooden staircase, and crashing through a sugar-glass window in a stage set to be built in the artist's backyard.

As one ponders the proposed pictures of Kersels and the Kouros, the metaphors mount up: wrestling with history, buried in history, bearing the weight of history, shrugging off the burden of history. What does the artist intend? "Grappling with history is an apt description of what I am thinking about." he says. "But I am also thinking of the Kouros not so much as an opposing force, but more as a partner. And that's why in the photos, I want to try to stay in physical contact with the figure—as if we were partners in an absurd, rough dance—like the taxi dancers on old television variety shows, who displayed a kind of beauty and grace in moments of unmodulated loss of control."

Kersels is pleased that the Museum has agreed to install the actual Kouros in the *Departures* exhibition alongside his somewhat irreverent photographs and, if it survives the photo shoot, the foam body double. "After all," he says, " I am aware that I may not be showing the Kouros to its best advantage— in the air, in the wrong light, in the wrong hands. In my hands. With me, personally." He pauses and then mugs, "I don't know why I think that way. Bad self-esteem, I guess."

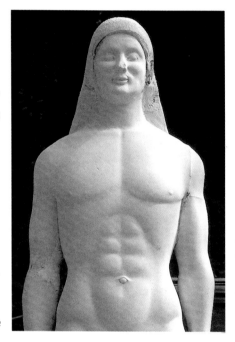

Detail of foam Kouros for
Martin Kersels's project,
in progress, November 1999

JOHN M. MILLER

PROPHECY

SANCTUM

ATONEMENT

For nearly thirty years, John M. Miller has devoted himself to creating abstract paintings that are as rigorous and demanding as they are beautiful. From one work to the next, he has explored a single compositional format in continuing variations: a rhythmic structure of hard-edged bars of color on raw canvas. Since 1973, Miller has never varied from this deceptively simple structure; making only subtle adjustments to the color, placement, size, and proportions of its elements, he achieves surprisingly dramatic differences in how the overall structure is perceived. For some artists, such rigid limitations would be inhibiting, but Miller believes that within his self-imposed boundaries lies his freedom, and, considering the quality of his production of the past three decades, one has to concur.

No external doctrine governs the development of Miller's art. He concentrates on one painting at a time and studies his preceding compositions to determine the direction he will subsequently take. As Miller puts it, "the paintings are my only mentors." Nonetheless, he allows that his sensibility is continually being shaped by a variety of influences. He is, in particular, a lover of books, so it is not surprising that he turned to a book for inspiration when invited to propose a project for the *Departures* exhibition.

After examining several manuscripts in the Museum's extensive collection, Miller selected the Hours of Simon de Varie. Made for a high official at the French court in 1455, this prayer book includes four miniatures illuminated by the greatest French painter of the fifteenth century, Jean Fouquet. Miller focused on a pair of facing pages that portray the donor, Simon de Varie, kneeling in supplication before an enthroned Madonna and Child.

In a recent conversation, Miller explained that he has always valued the uniquely intimate relationship that an individual can have with a book; and, although visitors to the Getty are not allowed to handle the Hours, he found it easy to imagine the immense pleasure that its original owner must have felt as he held the precious volume and studied its magnificent images at close range. Miller also appreciated the formal qualities of the Fouquet illuminations—the strong geometric base on which the figures are constructed, the subtle calibration of the hues, and the syncopation of floral motifs in the gridded borders. But, above all, he was fascinated by the manner in which Fouquet capitalized on the diptych format to imbue the images with paradoxical conceptions of both time and space.

The continuous grid pattern of the floor in the miniatures, Miller noted, implies that the Madonna and donor occupy a common dimension and, therefore, that the scene depicted is a real event happening in real time. Yet the disparate backdrops suggest otherwise. The gray stone wall behind the donor evokes the secular, earthly plane, while the sumptuous red drapery behind the Madonna and Child suggests the regal precincts of heaven. As art historian James H. Marrow has observed, the implication is "that this is an imaginary event—a visualization, as it were, of the donor's prayerful state and of the focus of his pious exercises."[1]

These temporal, spatial, and narrative dichotomies are reinforced by the rendering and positioning of the figures within the scenes. Simon de Varie's static pose and fixed, contemplative gaze, conveying prayer and meditation, contrast sharply with the animated expression and stance of the Christ Child, who actively reaches out toward the donor. Strong diagonals within the composition create a diamond-shaped structure that tends to unite the otherwise isolated

JEAN FOUQUET
Simon de Varie in Prayer before the Virgin and Child, 1455
Tempera and gold on parchment
JPGM, Ms. 7 (85.ML.27), fols. 1v–2

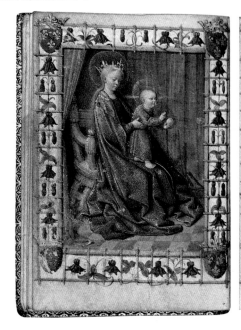

figures. Some vectors, however, do not intersect within the painted scenes. Instead, they meet and, like de Varie's gaze, appear to hover in the indeterminate space between the two pages. Thus, as Miller notes, the viewer is subtly but surely compelled to project himself into that breach, into a place where mortality encounters divinity and time is eternal.

A similarly complex sense of time and space characterizes the suite of works that Miller has created for the *Departures* exhibition: *Prophecy*, *Atonement*, and *Sanctum*. Although each work consists of several panels tightly butted together—three in the case of *Prophecy* and *Atonement*, and five in the case of *Sanctum*—Miller does not refer to them as multi-panel paintings; rather, he calls them two-division and four-division paintings. As critic David Pagel has remarked, "this distinction is important, for it suggests that Miller is more concerned with how boundaries are drawn (and redrawn) than with making discrete, autonomous objects that can be peered at from a safe psychological distance, under the guise of objectivity."[2]

Miller is quick to point out that, despite his choice of titles, his paintings "are not intended to narrate a specific religious experience." In contrast to the Fouquet diptych that served as his point of departure, he says, "you can bring only your own stories to these paintings." He acknowledges, however, that a number of factors infuse his austere works with decidedly spiritual qualities.

In the *Departures* exhibition, the paintings are installed according to the artist's specifications on three walls of a rectangular space. Viewers entering the room first encounter *Prophecy*, whose three panels carry bars of a uniform golden-ocher hue. On the facing wall hangs its identically sized companion, *Atonement*, a field of blood-red bars. Taken together, the paintings suggest the opposition of mind and body, cerebral enlightenment and physical passion.

The centerpiece of the suite is *Sanctum*. Nineteen feet in length, this magisterial painting comprises five vertical, raw-canvas panels, across which file evenly spaced rows of long diagonal bars interspersed with pairs of shorter, more steeply angled elements. Each panel carries bars of a single color: dark gray at either end, then deep violet, and warm white at the center.

Initially, the energetic composition of dark and light bars marching across the canvas ground may jolt your vision,

JOHN M. MILLER
Prophecy, 1999

even jangle your nerves. But, as its title suggests, *Sanctum* (like the Fouquet diptych that Miller admires) invites you to turn your attention inward. With time and concentration, the superficial cacophony of the tautly structured plane gives way to a profound sense of serenity and order. Bracketed by panels of darker tones, the central white panel reads simultaneously as a column of pure, bright light and as a portal that draws one's whole body, rather than just the eyes and mind, into a numinous experience.

Standing in the midst of Miller's vivid abstractions, you become a participant in a slowly unfolding event, or, as the artist describes it, "a moment in flux," in which distinctions between internal and external phenomena become diffuse, then re-form, only to dissipate again. Your senses are challenged and sharpened; your thoughts gain clarity. Given the right frame of mind, you begin to examine not only what you are seeing, but how you are seeing, and, ultimately, the very nature of your consciousness.

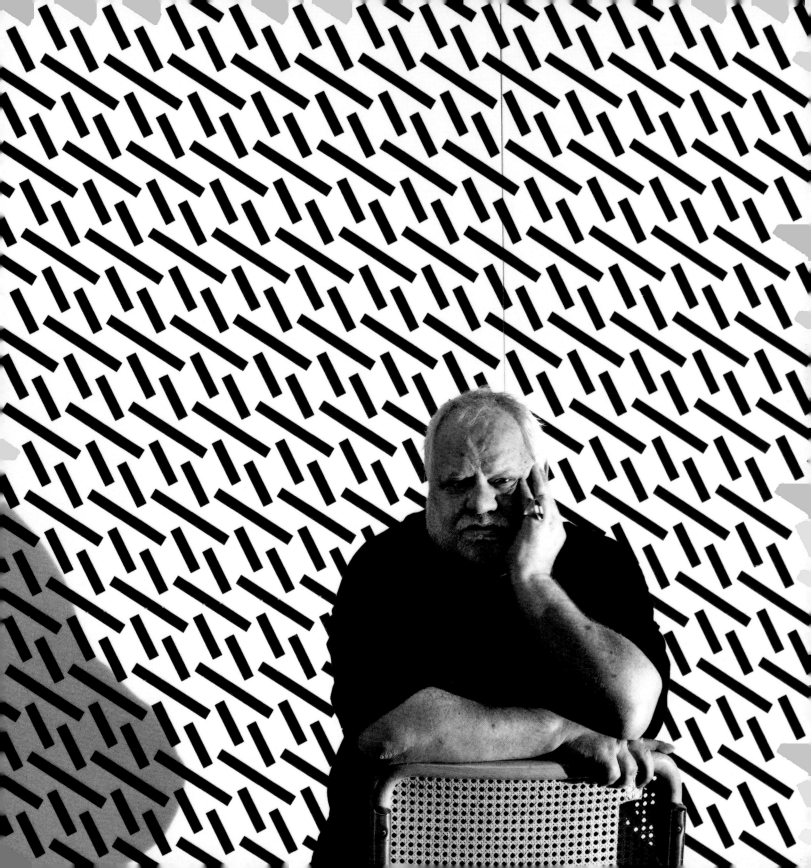

RUBÉN ORTIZ TORRES

LA ZAMBA DEL CHEVY

Let's play *Jeopardy!* Did I hear you say that you'll take REVOLUTIONARY HISTORY for $800? Okay, the answer is: A 1960 CHEVROLET IMPALA. Now, don't forget to phrase your response in the form of a question!

There's the buzzer! Give up?

The correct response is: WHAT CAR DID THE REVOLU-TIONARY HERO CHE GUEVARA DRIVE?

Yes, that's right. Che Guevara drove a Chevy Impala.[1] It's one of those odd little facts that just doesn't "compute" very easily when you first hear it. On the one hand, we have Ernesto Che Guevara, the asthmatic son of an aristocratic Argentine family who became a socialist revolutionary. The valued comrade-in-arms of Cuba's Fidel Castro, leader of guerrilla warfare in Latin America and Africa, and opponent of U.S. influence in the Third World, he was murdered by army troops while leading an attempt to overthrow the Bolivian government in 1967. On the other hand, we have the Impala, the all-American car with a reputation for performance, quality, and old-fashioned value, the automobile that Dinah Shore invited television viewers to buy in commercials on her weekly variety show with the snappy patriotic jingle, "See the U.S.A. in your Chevrolet!" Hard to wrap your brain around the concept, isn't it?

And yet, you have to admit that there is a certain kind of cosmic perfection to the image of the *Comandante* cruising the streets of Havana in his Chevy. Even to those without Marxist sympathies, Che was a dashing, charismatic figure, the revolutionary with rock-star good looks. Although he was killed more than thirty years ago, he remains a powerful icon of the sixties whose image is endlessly replicated on T-shirts and posters hawked on sidewalks around the world. The Chevy Impala is no slouch in the icon department either. As the *New York Times* writer James G. Cobb observes, "Of all the symbols of the 60s—peace sign, marijuana leaf, electric guitar—the one that came closest to home for many Americans was a stylized antelope leaping over a chrome hoop. It was affixed to some 8 million Chevrolet

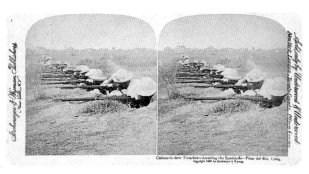

A View of Cuba during the Spanish-American War, ca. 1899
Stereograph (New York: Strohmeyer & Wyman)
Getty Research Institute, 95.R.22

Impalas in that decade."[2] Among today's baby boomers, Impalas are highly collectible icons of "youth misspent at the wheel, under the hood, in the back seat,"[3] and the Impala two-door convertible, a "bad ride" if there ever was one, is the model of choice among the most inventive of all automobile customizers, the lowriders.

So it really does make sense that Che would choose to drive a Chevy. After all, one great icon deserves another.

If you can buy that logic, then you are beginning to think like Rubén Ortiz Torres, whose project for the *Departures* exhibition, *La Zamba del Chevy,* turns on his uncanny ability to make beautiful sense of Che and his Chevy and other wonderfully bizarre cross-cultural collisions. A Mexico City–born graduate of California Institute of Arts who has lived in Los Angeles since 1990, Ortiz is the enormously imaginative producer of works in various media—photography, film, video, painting, and installations. United more by sensibility than by style, his diverse creations blend quirky manifestations of Latin and American art, history, politics, myth, and popular culture into stimulating visual and conceptual cocktails that can leave you feeling intoxicated by their heady mix of intelligence, humor, and energy.

Invited to propose a work for the *Departures* exhibition, Ortiz chose to investigate the vast holdings of the Getty Research Institute (GRI). He spent weeks getting pleasantly lost in the collections, poring over items ranging from Renaissance engineering drawings to Italian Futurist manifestos, from Russian Constructivist documents to pictures of Peruvian monuments.

Over time, Ortiz narrowed his focus to the GRI's Latin American holdings, and one day he found himself looking at a box of nineteenth-century stereographs. They showed views of Cuba during the controversial Spanish-American War, waged by the United States against Spain in 1898, which had grown out of the Cuban struggle for independence. He was immediately attracted to the photographic cards, each bearing two images of the same subject taken from slightly different angles; together they produce an illusion of three-dimensionality when viewed through an optical device known as a stereoscope. Ortiz had been fascinated by 3-D pictures since childhood, when he peered through the dual lenses of his View-Master and got his first glimpse of America and its culture—scenes of Arizona's Petrified Forest, Disneyland,

and Casper the Friendly Ghost—in high relief. The Cuban stereographs interested him as relics of an obsolete technology that was used not simply for aesthetic purposes but also for the production of salable travelogues and documents providing compelling evidence of important events. "I see the contents of the Cuban box as a kind of turn-of-the-century CNN television documentary," Ortiz explains. "It includes images of the war, the Spanish soldiers, the Cuban rebels, Teddy Roosevelt and the Rough Riders, as well as pictures of how people lived in Cuba, of the sugar plantations, and of the cities. Although there is no narration or prescribed order to the pictures, they tell a whole story."

The images of Cuba also played into Ortiz's long fascination with the culture of the island and with its geopolitical significance, which had been impressed upon him from a young age by his parents. "In the sixties, the Cuban Revolution seemed an option for the Third World," says Ortiz, whose architect father had been a member of a well-known Mexican singing group called *Los Folkloristas*. The elder Ortiz composed a wildly popular anthem to Guevara, *La Zamba del Che*, which was recorded by the celebrated singer Victor Jara, who was later killed for his political beliefs following a bloody military coup in Chile in 1973.

As he continued to study the stereographs, Ortiz realized that he had found the point of departure for his project, for they represented a nexus of many of the personal, political, aesthetic, and technological issues that have long interested him. And, consistent with the theme of the exhibition, they provided him the opportunity, he says, "to rethink history on many levels: history as a personal thing—my relationship with my family; history in a general sense—as a history of the relationship between the Americas; and the history of the evolution of technology and representation."

The result of this rethinking will be *La Zamba del Chevy*, a two-part work comprising a 3-D video projection and a 1960 Chevrolet Impala lowrider. The sound track for the video—and for the performances of the customized car, which will be parked on the Museum Plaza—will be a techno version of his father's anthem to Che produced by Uruguayan rock artists Carlos Casacuberta and Juan Campodónico. His dad's mournful *zamba* is sounding pretty good to him these days, admits Ortiz, whose teenage rebellion included turning his nose up at *Los Folkloristas*' "songs about condors flying over the Andes

and our brothers in revolution" in favor of urban punk music.

The car is currently undergoing customization at the hands of the famed lowrider Salvador "Chava" Muñoz, with whom Ortiz worked on a previous project. Entitled *Alien Toy*, 1997, it features a Muñoz-customized car that fragments into several bouncing and spinning pieces while serving as the pedestal for Ortiz's boisterous music video of the car performing. "The Getty lowrider will be a classical, radical dancer," says Ortiz, who explains that "each wheel will have an independent hydraulic system, so the car will be able to dance from front to back, from side to side, and will jump high on all four wheels." The exterior will be painted with a gaudy, candy-green and metal-flake camouflage pattern, a reference to the jungle fighter, Che, and his green Impala.

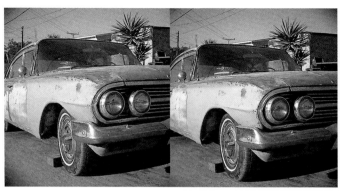

Stereograph of Chevrolet Impala prior to customizing for *La Zamba del Chevy*, 2000

Ortiz is traveling to Havana to shoot the *Comandante's* mint-condition sedan in 3-D video at El Museo del Automóvile, where it is the star of an otherwise motley collection of automotive relics from Cuba's past. Back in Los Angeles at the Getty Museum, Che's car will take another star turn, metamorphosing on the video screen into Ortiz's balletic lowrider, which will appear to leap into the laps of viewers wearing 3-D glasses of a Cold War–era design. The artist plans to shoot the customized car performing in front of a 1960s mural in an East L.A. housing project that features a portrait of Che looking more Chicano than Argentine. Such customization of the icon, Ortiz says, seems appropriate in this lowrider-heavy neighborhood. Ortiz's five-minute "music video," which will run on a continuous loop, will likely also feature footage of the annual parade of lowriders that takes place on New Year's Day in Pasadena, intercut with views of the classic American cars that still dominate the streets of Havana. Images of the artist's father singing and of the stereographs that set the new work in motion will probably also be included. Listening to Ortiz talk about the multi-layered project, you can almost hear his synapses snapping as he choreographs the chain reaction of images and ideas to the sound of the lowrider's hydraulics set to a *zamba* beat. It's the sound of history being rethought—and history being made.

following pages: Rubén Ortiz Torres, November 4, 1999

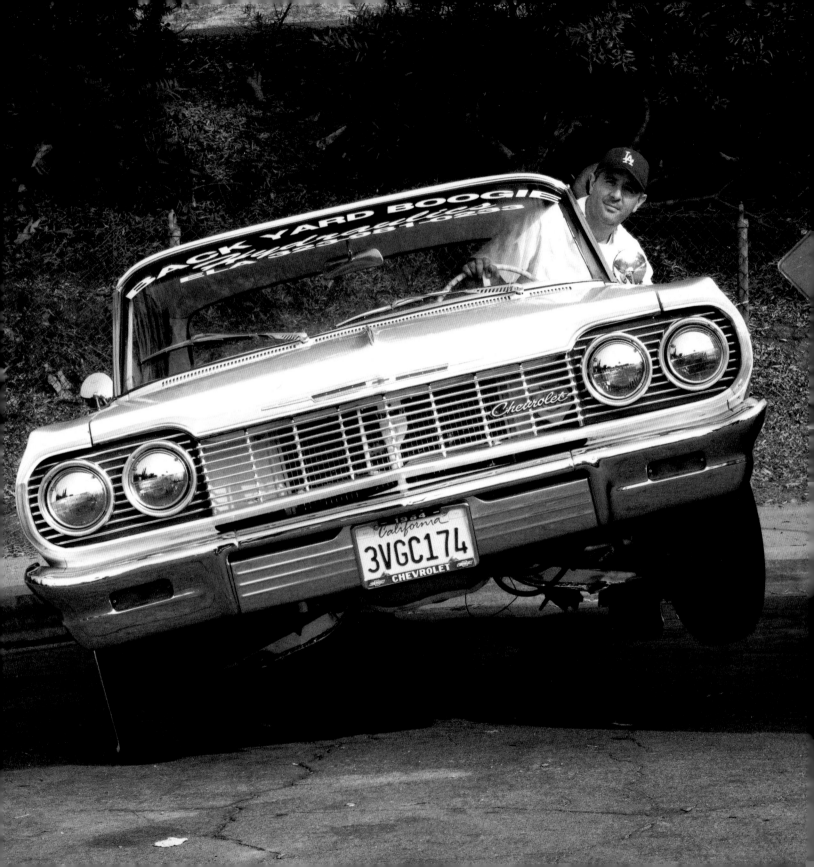

LARI PITTMAN

INDEBTED TO YOU,
I WILL HAVE HAD UNDERSTOOD
THE POWER OF THE WAND
OVER THE SCEPTER

Taking a seat in Lari Pittman's studio, I notice a piece of paper tacked to the wall, bearing a list of eight statements penned in capital letters. The first seven entries, the artist explains, are the titles of paintings he has recently completed. The final entry is the title he is contemplating for his painting for the *Departures* exhibition, which he has been working on for just less than a month. It reads: "Indebted to you, I will have had understood the power of the wand over the scepter." Studying the painting, which hangs across the room, I find few clues to the meaning of the projected title, with its cryptic acknowledgment of obligation and future accomplishment. There are no wands or scepters in sight, although, to pursue the metaphors suggested by the two words, the picture is invested with a measure of magic and authority even in its early stages. Composed of five contiguous, 8-foot-high panels and spanning more than 26 feet, the monumental work-in-progress has already begun to exude the kind of finesse and grandeur that is typical of Pittman's best efforts and that one associates with heroic painting of an earlier time.

Since he first came to prominence in the early 1980s, Pittman has developed a reputation as one of the most gifted American artists of his generation. With their lushly decorated surfaces, vivid colors, and dizzying compendium of abstract shapes and zany images drawn from popular culture and infused with personal meaning, his paintings are simultaneously exhilarating and enigmatic. His pictures of the past two decades are also highly political, and taken together they constitute an illuminating homosexual polemic on a wide range of social and cultural issues.

In preliminary discussions about his *Departures* project, Pittman expressed interest in creating a painting that would reflect his affinity for James Ensor's hallucinatory masterpiece, *Christ's Entry into Brussels in 1889*. It seemed a fine choice for a painterly response, especially as Ensor had produced his work in 1888 partly in reply to the work of another artist—the French painter Georges Seurat. Although the pioneering Pointillist's expansive canvas, *Sunday Afternoon on the Island of the Grand Jatte*, 1884–86, had met with critical acclaim when it was exhibited in Brussels in 1887, Ensor took exception to the painting's cool style and "its conception of a placid, classless society blandly enjoying leisure-time diversions on the banks of the Seine."[1]

In addition to the Ensor, Pittman noted that he could also be counted on "to refer to some other more degraded aspect of the collection." When visiting a museum, he explains, he looks to the creations of his predecessors to find a reflection of himself as a contemporary artist. "But it's usually difficult to find it historically," says the artist. "Maybe I will catch just a glimpse, here and there." He notes that he is generally more successful in his search when perusing museum galleries dedicated to the decorative arts, particularly glass, porcelain, and furniture. "It often seems that I can see myself in the reflection of a teacup more than in a great painting," he observes. Then, too, he finds that he is attracted to art that is "mannered, art that is a little over the hill, as opposed to art of the highest classical moment," believing that such work "exhibits a greater degree of human pathos." In that regard, he mentions his interest in an affecting group of second-century-A.D. Fayum mummy portraits at one time installed at the Getty Villa. "The pathology of a culture is clearer in those more mannered moments," Pittman observes, "and that gets into my own psychology a bit more."

Now, several months since Pittman first contemplated the *Departures* project, a poster of *Christ's Entry* is pinned at the far end of his studio wall. The poster is a recent acquisi-

JAMES ENSOR
*Christ's Entry
into Brussels in 1889*, 1888
Oil on canvas
JPGM, 87.PA.96

tion, but Pittman's appreciation of Ensor's painterly manifesto on the state of Belgian society and modern art in the late nineteenth century is long standing. As critic Christopher Knight has pointed out, Ensor's "flood of masked celebrants and leering grotesques" finds echoes in Pittman's *Untitled #1 (A Decorated Chronology of Insistence and Resignation)*, 1992, a four-panel narrative of sex, death, and redemption in which marching puppets "convey a determined, even spooky reverie in the face of chaos and decay."[2]

"One of the thrilling things for me about the Ensor is that it is an incredibly modern painting, especially when you consider the date—1888. It's stunning," Pittman says. "It's not so much its physical comportment as a painted object, but more how it functions conceptually. I am thrilled by the fact that, in a work of this period, the subject of the painting is not the content of the painting." By its title, Ensor's work masquerades as a depiction of the second coming of Christ. "But that is not at all what the painting is about," Pittman observes, explaining that the work "upsets a profound tradition, not depicting Christ as the protagonist of the picture, but using him as a decoy, as a ruse to explore other, secular issues." He describes this separation of purported subject and actual content as an example of "drag." Pittman explains: "Although it's not a strictly homosexual strategy, it can be understood in the context of classical drag. When you see someone impersonating Barbra Streisand, no one ever believes that the event you are witnessing *is* Barbra Streisand. Instead, to appreciate the event, you are called upon to automatically split the subject and content apart, and that is the only moment in which the event of drag can be pulled off."

Pittman views *Christ's Entry* "not as a painting but as a tableau," noting that he is interested in its stridently artificial, stage-set-like qualities. And indeed, both conceptually and formally, the composition is a highly theatrical invention. Although he painted the picture in 1888, Ensor set the second coming of Christ in the Belgian capital one year later, and he included in his strange procession contemporary public figures, friends, and family members, as well as historical and allegorical personages. The scene is presented frontally, splaying out across the horizontal canvas as if on a vast stage, while the thronging cast of bizarre characters is arranged in a steep, wide-angle perspective. The rush of

images can virtually engulf the viewer, and, confronting the work, Pittman notes, "one can get lost in the delirium of its abstraction." Much the same can be said of many of Pittman's own works, with their dense, eye-popping networks of decorative patterns and images coursing across their surfaces.

At this writing, Pittman's painting for the *Departures* show is still in its infancy, and there is as yet little sense of such delirium on its five panels. For now, the painting is displaying its "good bones." Pittman began by covering the entire surface of the gessoed panels with a broad patchwork pattern of closely valued shades of blue, green, and brown paint, applied with rollers that have left impressions resembling tire tracks. Against this backdrop of what he refers to as "retail color," he has introduced portraits of five men, based on the type of head-shot photographs of hairstyle models that are often displayed in neighborhood barbershops and salons. Rendered at vastly magnified scale and in a simplified, illustrational style, at this point they suggest slightly more individualized versions of the generalized personalities that inhabit the paintings of such Pop artists as James Rosenquist and Roy Lichtenstein. There are some curious additions to the standardized portraits, however. A mustachioed man seen in three-quarter profile sports a crown of leaves, as does the man to his left on the central panel. (It is tempting to read these as a reference to the laurel wreaths worn by the figures in the Getty's Fayum portraits, although the motif has appeared previously in several Pittman paintings.) Both figures also wear veils, a traditionally feminine and exotic piece of attire, which Pittman views as a symbol of expertise in understanding delicate issues of covert power. The ability to operate in this highly nuanced arena, he notes, is associated historically with women and with gay men.

Positioned at irregular intervals across the canvas stand a collection of curious objects with hybrid identities: part vessel, part oil lamp, part incinerator. Bright yellow flames issue forth from some of the burners and spread across the panel. Reading the picture from left to right, the waxing and waning flames set up the basis of a narrative suggesting a cycle of human desire and passion. But there is much more to come, for, right now, Pittman is wielding his brush with the transformative power of the wand and the command of the scepter.

LARI PITTMAN
Detail of *Indebted to you,
I will have had understood
the power of the wand
over the scepter,*
in progress, November 1999

following pages: Lari Pittman, November 1, 1999

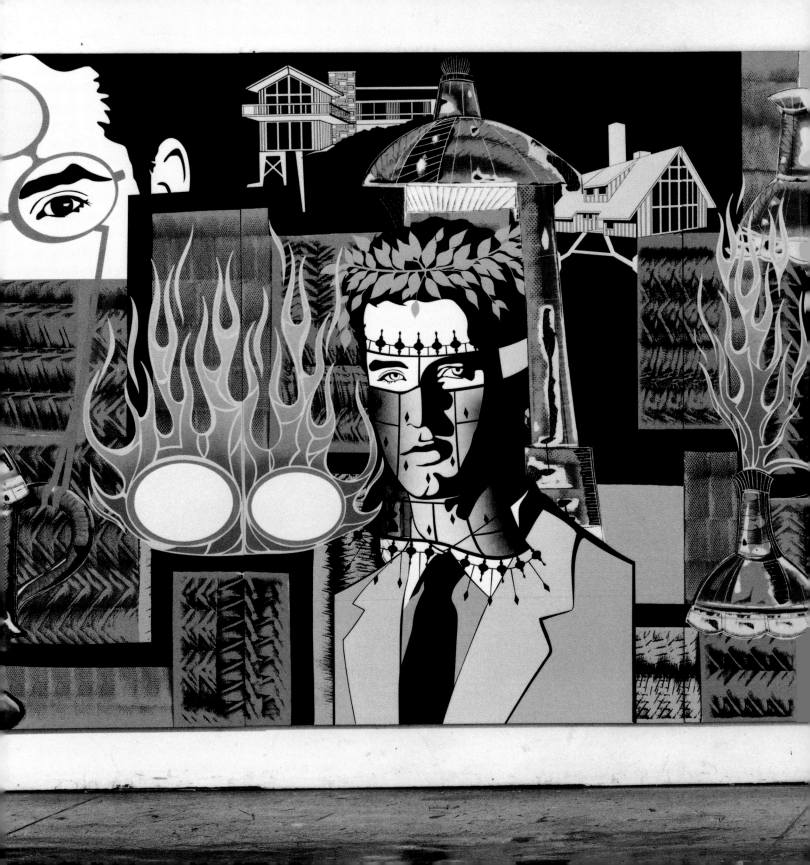

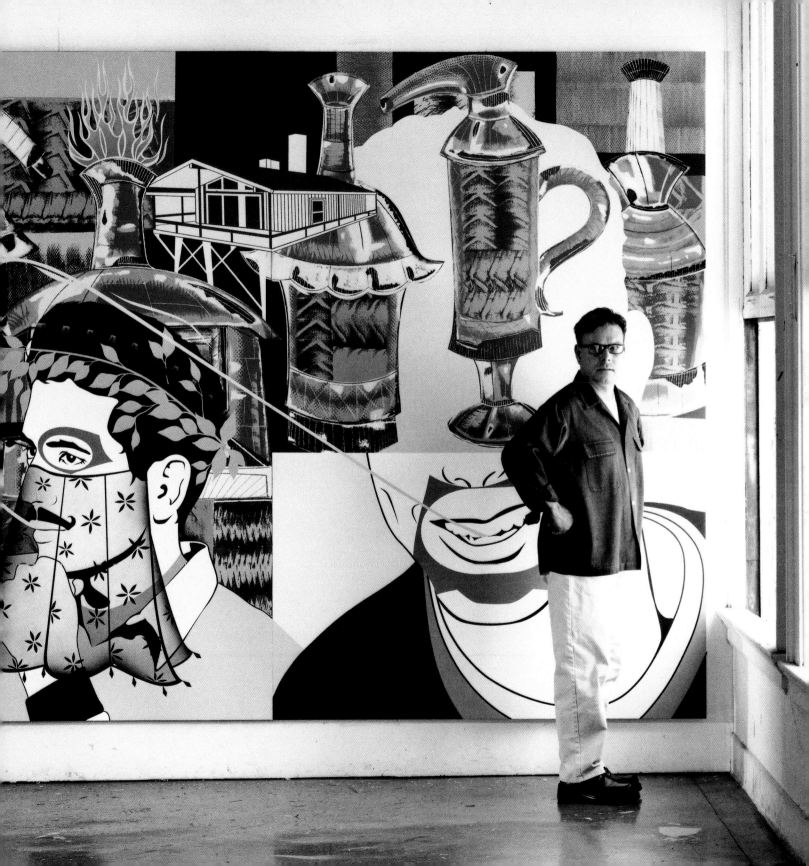

STEPHEN PRINA

VINYL II

On a Monday morning in October 1999, when the Getty was closed to the public, the cast and crew of *Vinyl II*, a film by Stephen Prina, began to assemble on the upper level of the Museum's East Pavilion. Before the day was over, the sounds of a string quartet and a French horn, playing an original musical score composed by Prina, had wafted through the pavilion. And Prina, who had spent the morning behind the camera, conferring with the members of the production company, had stepped before the lens to perform a lilting pop song he had written.

Stephen Prina is often described as a Conceptual artist, but, as an observer of the film shoot, I was struck by the inadequacy of the term to define the scope of his activities during the past twenty years. True, Prina's work is idea based, and his diverse creations—which range from photographic wall works to mixed-media installations to performances and recordings—are united more by philosophy than by appearance. Yet, with one foot planted firmly in the world of high art and the other in popular culture, Prina has always produced work that transcends simple designation as a strictly cerebral art of the mind.

Prina, who was born and raised in the small town of Galesburg, Illinois, has been making art for most of his life. Among his most cherished possessions is a childhood gift from one of his brothers, a picture book entitled *100 of the World's Most Beautiful Paintings*. At the age of twelve, he made a copy of his favorite picture in the book, the one called *Saint Joseph the Carpenter*. The Prina version still hangs in his mother's apartment; the original, known as *Christ with Saint Joseph in the Carpenter's Shop*, circa 1635–40, hangs in the Musée du Louvre, Paris. It is the work of Georges de La Tour, the French painter of religious and genre subjects who is best known for his night scenes of dark interiors illuminated by candlelight.

Music was Prina's second love. Throughout high school, he played in rock bands, although, as he says, he became "quickly disillusioned with pop and moved on to jazz fusion and experimental music." After receiving a bachelor's degree from Northern Illinois University, where he majored in painting and minored in music, Prina moved to Los Angeles in 1978

GEORGES DE LA TOUR
The Musicians' Brawl, ca. 1625
Oil on canvas
JPGM, 72.PA.28

GERRIT VAN HONTHORST
Christ Crowned with Thorns, ca. 1620
Oil on canvas
JPGM 90.PA.26

to enter the graduate program at the California Institute of Arts, then known as a hotbed of Conceptualism and theory. He began "reconfiguring compositions by [Arnold] Schoenberg into sound installations," says Prina. "That work marks the beginning of an interest in appropriation. . . . I stopped looking for neutral materials to work with and started using materials that already had a history, which I played off of."[1]

Since those early days, Prina has mined numerous sources for the subject matter of his creations, which often focus on the ways in which works of art and our appreciation of them are shaped by institutionalized value systems. Prina is not especially concerned that his audience can rarely fathom all the references within his multi-layered pieces. "Different aspects hit their marks with different viewers," he observes.

That will surely be the case with Prina's film for the *Departures* exhibition, *Vinyl II*, with its dense web of allusions and associations. It was inspired by his continuing appreciation of the art of Georges de La Tour, the painter he had copied as a child. "I wanted to go back and investigate what held my interest," says Prina. Consequently, when he visited the Getty to consider sources for his *Departures* project, he headed for the East Pavilion to view *The Musicians' Brawl*, an early painting by La Tour in which a pair of elderly itinerant musicians fight over a place to play their instruments. "It's a wonderful painting, but it's not what I look for in La Tour—it's not a nocturne," says Prina, betraying his admiration for La Tour's theatrically lit, signature night scenes.

In the adjacent gallery, Prina discovered a painting by Gerrit van Honthorst, *Christ Crowned with Thorns*, in which a torch illuminates the image of Christ humbly accepting the mocking of ignorant mortals. Here was the theatrical nocturne he was looking for. "I didn't know much about Honthorst in my formative stages of development, so the Honthorst didn't hold the same attraction as the La Tour," he says. "Yet many of the elements that I look for in La Tour—but are absent from *The Musicians' Brawl*—are in the Honthorst. The idea of that lateral shift interested me."

That shift, with its tug of emotion, memory, and intellect, became the point of departure for *Vinyl II*, Prina's 21½-minute, 16-mm color film, which will screen daily in the Museum's lecture hall during the run of the *Departures*

exhibition.[2] The film consists of two roughly 10-minute shots, the first filmed in Gallery E201, the second in the adjacent gallery, E202, followed by a 90-second title sequence. It opens abruptly and in near silence with a tight, minute-long close-up of a portion of the Honthorst painting that features the torch and Christ's naked upper torso and left hand. Thirty seconds into the shot, the sound of a string quartet and a French horn is heard playing a note in unison. Then, an approximately 6½-minute-long, extremely slow, motion-controlled zoom-out begins, and as the lens pulls back, more and more of the room is revealed. At the west end of the gallery, near the Honthorst painting, we see the seated string players performing at their lighted music stands; a security officer stands in the far right corner. Six microphones are positioned in two parallel rows along the length of the room.

The music begins on an F note played in unison, but the instruments introduce additional pitches that broaden the harmonic range and produce a slowly permutating, slightly sour drone. After approximately 2 minutes, the instruments reach harmonic consonance, and the musicians play a pop song segment that lasts approximately 3 minutes, after which they gradually return to the unison note. At the 9-minute mark, the camera begins slowly tracking south, passing the French horn player, until it reaches the interior of the doorway, where it stops on the out-of-focus grain of the wood jamb. A cross-dissolve leads into the second shot, which begins again on the doorjamb. The camera tracks south into Gallery E202, past a Getty guard. Coming to rest in front of the La Tour painting, but facing away from it, it frames the string quartet and the French horn player, who are seated at their music stands on the far side of the room in front of Peter Paul Rubens's painting *The Entombment*.

The music performance closely duplicates that in the first shot, with one notable exception. During the pop song segment, Prina enters from stage left wearing a bright red jumpsuit, steps up onto a wooden box behind the sixth microphone, and, following the score with a flashlight, sings about the qualities that he associates with Georges de La Tour's work, but that are not evident in *The Musicians' Brawl*. After completing the song, Prina takes a seat and, when the music has returned to the unison pitch, the camera begins to pan to the left, momentarily hesitating on the doorway in the south wall of the gallery, and then continues until it completes a full 180-degree turn, focusing squarely on the La Tour painting. The film concludes with credits whose letters are composed of an image of flames on a black field.[3]

In style and substance, *Vinyl II* alludes to the work of several other filmmakers, among them Andy Warhol. Indeed, the title of Prina's film is a reference to the Pop artist's film, *Vinyl*, 1965, "a demented, black-humored takeoff on Anthony Burgess's novel *A Clockwork Orange*."[4] Consisting essentially of two long, stationary takes with an occasional zoom, *Vinyl* features Gerard Malanga dancing repetitively to a pop song and then being chained, shirtless, to a chair in a sado-masochistic scene. Prina was struck by the elegant simplicity of Warhol's use of repetition, and the image of Malanga in the chair likely suggested to him certain comparisons to the torso of Christ in the Honthorst painting, which, when seen in isolation in the closely cropped shot at the beginning of *Vinyl II*, exudes a vaguely erotic aura. With its long, slow zoom-out, *Vinyl II* also suggests comparison with Michael Snow's *Wavelength*, 1967, a 45-minute zoom across a room into a photograph of an ocean, while its static focus on individual paintings brings to mind the minimalistic works of the filmmakers Danièle Huillet and Jean-Marie Straub, whom Prina admires.

Ultimately, *Vinyl II* is the quintessential expression of Prina's idiosyncratic vision, which can be appreciated on many levels. Its combination of pop and classically inspired music—as if the Beatles, the Beach Boys, and Burt Bacharach somehow collaborated with Robert Schumann—is compelling in and of itself. With its beautiful, rigorously spare camera work applied to luscious Baroque subject matter and its rich mix of private and public, contemporary and historical allusions, the film is a work that causes one to reflect on many topics, not the least of which is how meaning itself is constructed. As Prina observes, "*Vinyl II* encourages a certain kind of speculation on spectatorship."

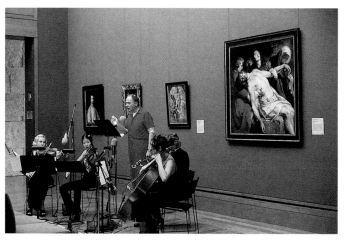

Stephen Prina and musicians performing in a Getty gallery during the filming of *Vinyl II*, October 4, 1999

A musette, fiddle, and a flute
A hurdy-gurdy player who seems blinded.

A fine bunch, yes, I love them all
Yet there's a reminder of what is missing.

A candle, flame, a twist of smoke
A hand illuminated from behind
So that it glows within.

—Excerpt of lyrics from *Vinyl II*, by Stephen Prina

following pages: Stephen Prina, October 30, 1999

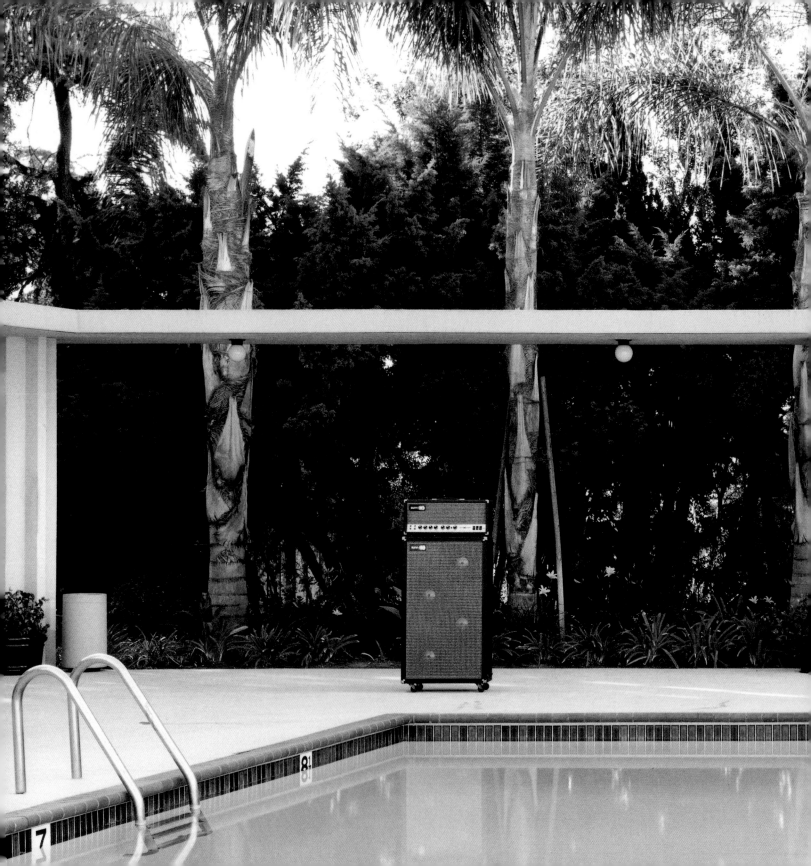

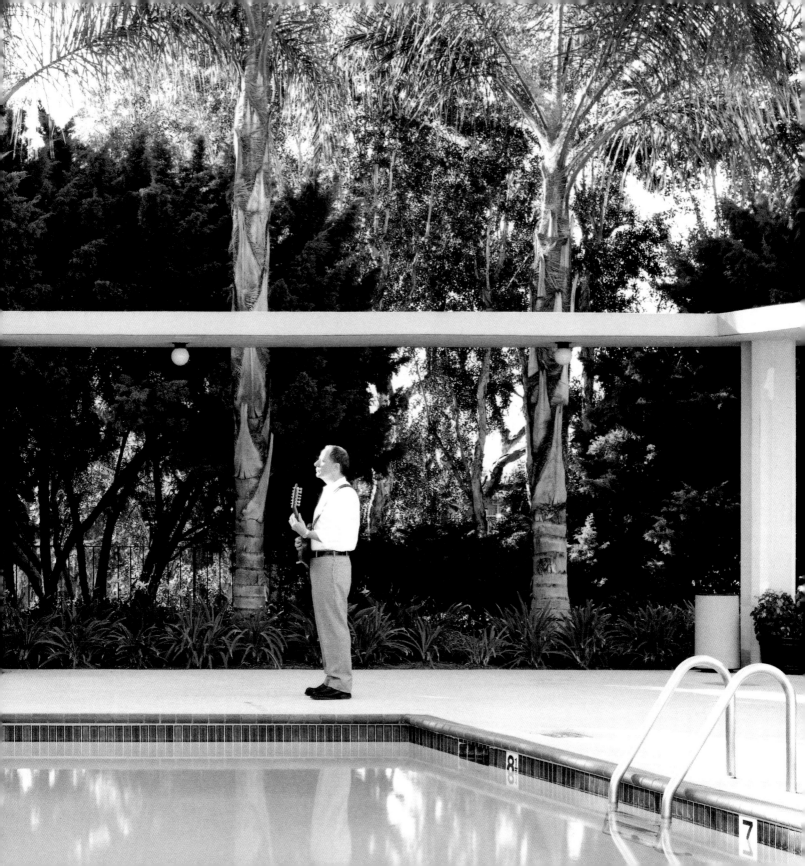

ALISON SAAR

AFRO-DI(E)TY

On a terrace behind her hillside home in Laurel Canyon, Alison Saar is using a chain saw and a chisel to coax a goddess out of a block of laminated lumber. As the sawdust flies and the wood chips fall away, the form of a 6-foot-tall female is slowly emerging from the timber column. When the carving process is complete, Saar will flesh out the deity's character with an array of found and specially fabricated adornments.

The larger-than-life-size figure taking shape in Saar's open-air studio is the latest in a series of provocative mixed-media works that she has created since the early 1980s. Products of her eclectic sensibility, which draws on her own multiracial heritage and on the art-making traditions of several other cultures, Saar's marvelously allusive sculptures are always greater than the sum of their parts. Each reveals their maker's ability to bring together seemingly incompatible materials and images and to infuse them with new and potent meanings.

Saar says that she was not especially familiar with the Getty's collection when she began to ponder her *Departures* project early in 1999. In years past, she had visited the Getty Villa, where she had admired the Museum's extensive holdings of ancient art. Consequently, when she went to the Getty Center to investigate starting points for a new work, she headed to the Museum's West Pavilion, where a selected group of antiquities are installed. Among the works on view is the Hercules (Lansdowne Herakles), a second-century-A.D. Roman copy of a fourth-century-B.C. Greek sculpture. It portrays the young hero, known for his astounding strength, holding the skin of the Nemean lion and carrying the club with which he stunned the beast before slaying it. Discovered in the late eighteenth century in the emperor Hadrian's villa in Tivoli and held until 1951 in the collection of the marquess of Lansdowne, this sculpture was one of J. Paul Getty's most prized acquisitions.[1]

Also on view in the West Pavilion near the Hercules is a monumental cult statue of a goddess of voluptuous proportions, thought to be Aphrodite. Considerably larger than life size and expertly sculpted from an unusual combination of limestone and Parian marble, the fifth-century-B.C. figure is an imposing presence.[2] Yet Saar found her attention focused less on the goddess than on the hero. "Hercules is given 'the standing' in the gallery," Saar explained in a conversation about her Museum visit. "He is centrally located, and by that placement you can get a sense of his enormous power and importance within the realm of Western myth and history."

Saar searched the selection of antiquities in the pavilion for potential departure points, but was disappointed, she says, "by the lack of diversity" within the Museum's holdings. "It is a strictly Roman and Greek collection; there are no Egyptian or African works," she observes. "And the few depictions of Africans in the antiquities collection—like the small slave figure shown in a twisted, cowering pose—seem to be almost derogatory caricatures."

Elsewhere in the Museum, Saar found a few sympathetic portrayals of individuals of Black ancestry. Perusing the galleries dedicated to European painting and sculpture, she was especially moved by Théodore Géricault's *Portrait Study*, circa 1818–19, which may depict Joseph, the professional model who posed for the nineteenth-century French painter's masterpiece *The Raft of the Medusa*, 1819, in the collection of the Musée du Louvre, Paris.[3] Nonetheless, in considering options for her *Departures* project, her thoughts were dominated by her impressions of the Getty's antiquities collection, which led her to consider not only how histories are constructed but also the values they help to generate and support. "I was intrigued by the power of the Greek and Roman pantheon," Saar says, "how all of Western civilization has placed such weight and emphasis on it, when there are, in fact, many other cultures with equally interesting and important deities." As she further contemplated a source for a new work, she found her thoughts continually running to Hercules. She bridled at the notion that the mythic hero is venerated as "an exemplar of human achievement,"[4] even though his famous twelve labors include a host of violent acts, among them bludgeoning to death Hippolyta, queen of the Amazons.

With these thoughts in mind, Saar decided to create a sculpture of a powerful female figure who would strike Hercules' pose, but would reflect a decidedly different spiritual mien. She called her creation *Afro-di(e)ty*, a witty play on the name of the Greek goddess of love, beauty, and sexuality. As her hyphenated appellation suggests, Saar's sculpture is conceived as an exotic, hybrid creature whose aesthetic ancestry extends past ancient Greece to encom-

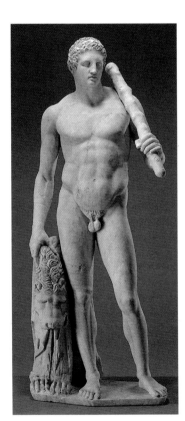

Hercules (Lansdowne Herakles)
Roman, ca. A.D. 125
JPGM, 70.AA.109

pass Africa and the far-flung outposts of the African diaspora throughout the Americas and the Caribbean.

In the *Theogony*, a genealogy of the gods written by the Greek poet Hesiod, Aphrodite is described as having sprung from the foam of the sea, a vision that has been depicted time and again through the centuries, but perhaps most memorably by the Italian Renaissance painter Sandro Botticelli (1445–1510). His *Birth of Venus*, circa 1482, portrays the goddess as a willowy blond creature carried to shore on a half shell.

Although she is interested in Aphrodite, the ocean-born deity of Western mythology, Saar is infinitely more intrigued by Yemaya, the nurturing mother goddess of the Yoruba people of Nigeria. As Saar explains, "She is the creation figure of the African diaspora, the mother of all deities, and the mother of the ocean." The patroness of fertility, birth, and creativity, Yemaya is worshipped primarily by women, and Saar, as both a mother and an artist, feels a particular affinity for her. "In her shrines, Yemaya's powers are often represented by river stones," she observes. "The manner in which the stones are molded and worn by water over time suggests the nature of her spirit. Unlike Hercules, who bludgeons his way through situations, she brings about change through rationality and persistence, and through patient acts of gentle cleansing."

Saar explains that in Africa altars for worshipping Yemaya tend to be white and red, alluding to the blood of childbirth, but in the Western hemisphere they are typically blue, white, and silver, colors evoking the sea and stars. "For the slaves who were transported across the ocean, that body of water is both a connection to and separation from so many things," she says. "Consequently, Yemaya, as a water deity and a patroness of the shipwrecked, became an important presence in the Americas, especially in coastal regions."

In contrast to her distant Renaissance cousin, who was borne to shore on an exquisite seashell, *Afro-di(e)ty* will arrive at the Getty Center in a humble container. Her muscular body, suggesting the athletic brawn of the Lansdowne Herakles more than the feminine charms of Boticcelli's *Venus*, will rise from a tin washtub. Rather than appearing to float on ocean foam, her feet will disappear below the tarnished surface of a mirror intended to conjure the dark and murky waters of a deep sea. Saar plans to supply the figure with several symbolic attributes that will identify her as the mother of waters. She will clad *Afro-di(e)ty*'s body in a patchwork skin of pieces of blue-oxidized copper, hammered in place with hundreds of tiny nails and streaked with white paint, a technique reminiscent of both African fetish figures and the gritty creations of urban American folk artists. A mirror set into her belly will suggest the generative waters of the womb. Even the figure's hair will convey her status as an ocean deity. Saar will fashion what she describes as "nappy dreadlocks" by poking twisted branches of bleached white coral into dozens of tiny holes drilled in the surface of the goddess's head.

In place of Hercules' club and lion's fleece, *Afro-di(e)ty* will bear a mirrored fan in her left hand, while a swath of wrinkled white fabric, evoking both a laundress's burden and a torrent of water, will stream from her right hand. Surrounding her will be piles of salt, supporting enameled white and blue basins filled with water, a detail borrowed from shrines to Yemaya. Behind her will hang a scrim, its surface ink-jet-printed with an image of an ocean filled with starfish and sand dollars. Clothespinned to a rope stretched across the gallery, the fabric sea will ripple in the breeze of a nearby electric fan.

Asked if she conceives of *Afro-di(e)ty* as a self-portrait, Saar says that, indeed, she does. "Actually, I think of all my sculptures as self-portraits, although they never look like me. They are all invented figures. But I think that they are self-portraits—even the male figures—in that they all discuss something that I feel emotionally. They are all, in some way, about being left out, about being outsiders." Her comment reminds us that *Afro-di(e)ty* was born in response not only to what Saar saw at the Museum but to what she did not see. She could not see her own reflection. If only for a while, *Afro-di(e)ty* will change that situation.

ALISON SAAR
Study for "Afro-di(e)ty," 1999

following pages: Alison Saar, November 8, 1999

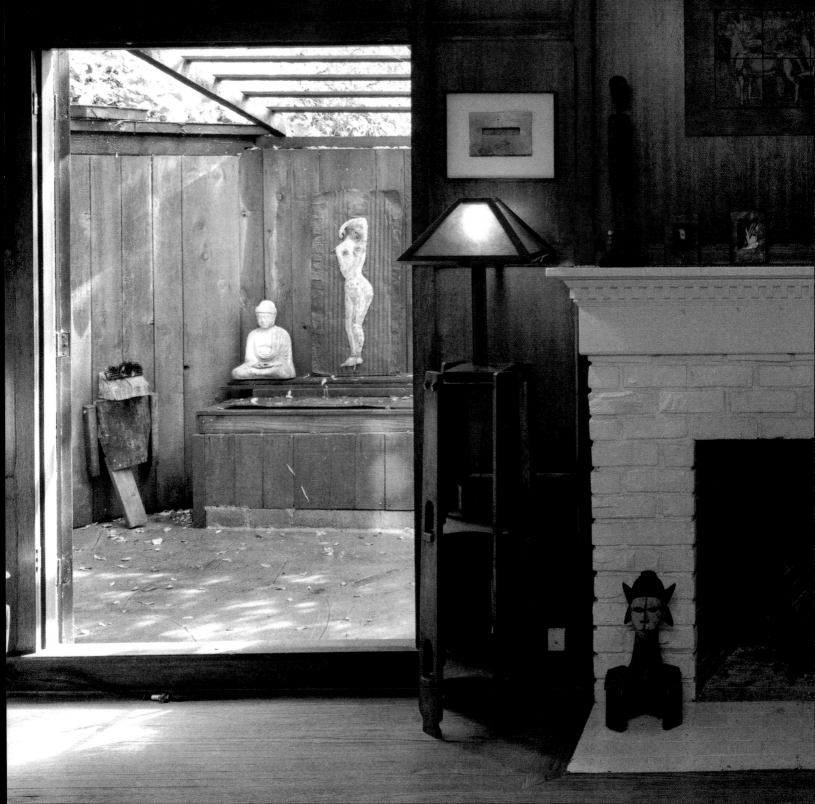

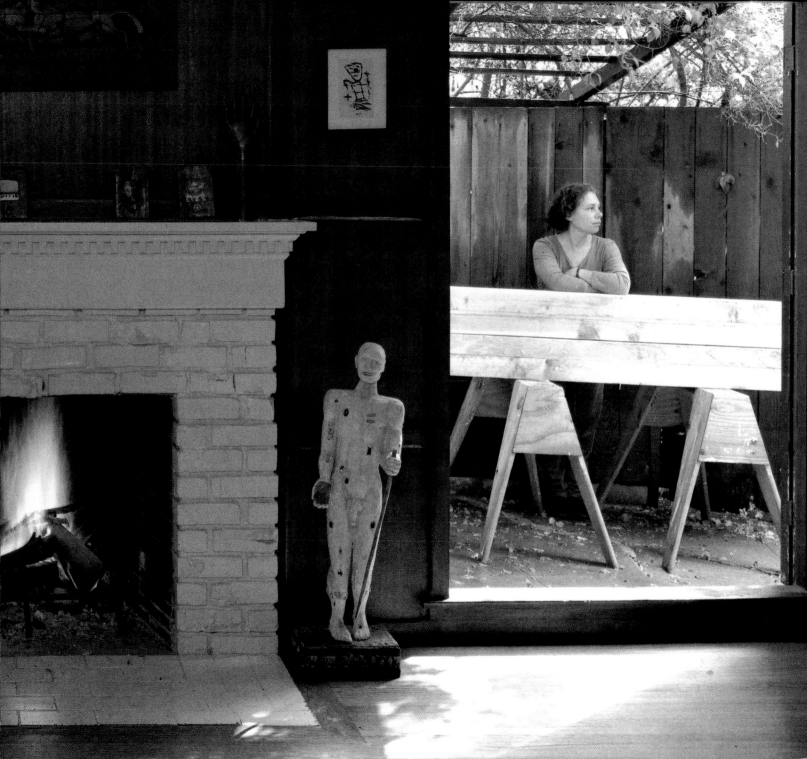

ADRIAN SAXE

One of a Pair of Torchères
Dutch, ca. 1740–50
JPGM, 79.DA.5.1–2

Center Table
Support, French, ca. 1745
Top, Italian, ca. 1600
JPGM, 72.DA.58

Adrian Saxe is a wide-ranging thinker with startling verbal abilities. Ask him a question about anything having to do with clay and buckle your seat belt, because the answer is sure to take you on a wild ride. In a conversation about his work-in-progress for the *Departures* exhibition, Saxe cast his response to a query about the projected finish of a porcelain vessel in the form of a fascinating exegesis on politics, history, and humanism. Along the way, he touched on technological advances in the Age of Enlightenment, the redefinition of Japanese aesthetics in the Momoyama period, and cross-cultural references in the films of Woody Allen.

Such leaps of imagination are standard fare for Saxe, the skilled creator of seductive, fantastically ornate objects in porcelain, stoneware, and other ceramic media. Often described as an artist whose subject is pottery, as opposed to a ceramist, he creates works that push the envelope of the medium, while pushing buttons in viewers' psyches. In his hands, the potter's standard repertoire of vessels is a vehicle for reflecting upon diverse aesthetic, philosophical, social, and political issues. Yet Saxe's works are never didactic because they are always leavened with dashes of devilish wit and outrageous bursts of goofy humor. These are pots with looks *and* brains, not to mention sex appeal, attitude, and a sometimes questionable sense of decorum.

During a conversation in his studio, Saxe discussed misconceptions about the field of ceramics and the way it is devalued in relation to other art forms. "The utilitarian side of ceramics' history is rather minor," he pointed out. "When you take the totality of the physical record into consideration, it's not about pots and tableware. It's mostly about art." Asked if there is one aspect of the clay tradition with which he feels the greatest affinity, Saxe responded: "I am interested in the whole collective history of ceramics. I am as interested in the traditions of China and Japan and the ancient Near East as I am in the traditions of Europe."

That said, Saxe allows that he has always had a particular fondness for eighteenth-century French furniture and for porcelains, especially the work of the Manufacture Nationale de Sèvres in France, where he served as artist-in-residence from 1983 to 1984 and again in 1987. He has a deep apprecia-

tion of the Getty's strong holdings in these areas, and he bemoans the tendency "to relegate the decorative arts to some elite arena of connoisseurship." In Saxe's view, the lustrous vessels and elaborately carved consoles should be more widely appreciated for their high degree of formal and conceptual inventiveness and for their consequent historical importance. "Modernism would not have happened without the Rococo," says Saxe.

Saxe has long been fascinated by garnitures, groupings of ormolu-mounted porcelains produced in Europe from the seventeenth to the nineteenth century. Symbols of wealth and sophistication, these typically comprise symmetrical arrangements of three, five, or seven vessels, with a central piece flanked by pieces of identical shape or size. The individual mounts are often alike, while the painted patterns on the porcelains sometimes vary considerably within a grouping.

For the *Departures* exhibition, Saxe is using the conceit of the garniture as a springboard, but he is upping the ante with postmodern strategies of appropriation, both in the manner of presentation of the pieces and in their vocabulary of forms. Drawing from a variety of historical sources, he is producing a collection of related vessels designed specifically to be displayed on pieces of furniture selected from the Getty's collection of eighteenth-century decorative arts.

In preparation for his project, Saxe examined several items in the Museum's galleries and storerooms before focusing on a gilded oak center table with a highly patterned, *pietre dure* (inlaid stone) top. The table base, with a carved design of scallop shells, winged serpents, and garlands of flowers, is of French manufacture and dates to about 1745. The top, which was probably made in Rome about 1600, was likely acquired by a young Frenchman during a Grand Tour of the Continent in the mid-eighteenth century.[1] It was not uncommon during that period to flank a center table with torchères, tall stands designed to display candelabra. Consequently, for his installation, Saxe has chosen a fine pair of gilded specimens in the Museum's collection that he has long admired for their decoration of dragons, scroll-like elements, cartouches, palm leaves, and floral branches.

At this writing, Saxe is in the early stages of creating his ambitious table garniture, comprising five large porcelains on a lava-like stoneware base, and a pair of related vessels for the torchères. With the Museum's permission, he is

replacing the table's *pietre dure* top with a new and far less decorative one fabricated of Numidian red marble. Its simpler form and more uniform surface, Saxe believes, will provide an appropriate bridge between the rococo base and his own contemporary work. As he puts it, "the new top is an object of agency . . . a device that serves as a representation of a transformative moment between the past and the present."

Saxe developed the forms of the vessels through a series of drawings, ranging from thumbnail studies of individual elements to broad sketches of the overall grouping. Next, he set to work with the assistance of Parisian artist Jean-Luc Degonde on the arduous process of carving full-scale models of each piece from 2-foot-tall, 250-pound blocks of solid plaster. Multiple-part plaster molds were made from these models for each piece in the garniture. The molds are currently curing, a drying process that requires about three weeks, and Saxe will soon begin casting the porcelains.

Meanwhile, the five carved-plaster models stand on a studio shelf, somehow suggesting both a row of eccentric buildings and a queue of jaunty characters, members of a stage play about to take a bow. In this state of undress, with no hint of the elaborate surface decoration yet to come, the prototype vessels flaunt their chunky but alluring figures. In their combination of curvilinear and geometric elements, the clean, white models display a distinctly Art Moderne quality. As Saxe explains, however, "these forms are a sort of intuitive Southern California chinoiserie." The scrolling and spiraling bas-relief elements and curvaceous profiles of each vessel derive in part from Saxe's idiosyncratic take on the mazes found on ancient Chinese bronzes, as well as from the stylized cloud and fungus designs found on Tang and Sung Dynasty pots. Likewise, the vessels' semi-organic shapes suggest those of Chinese "scholar's rocks," beautiful stones that are used as tabletop objects of contemplation and meditation.

Discussing his plans for additional embellishments for the vessels, Saxe reaches into one of the dozens of bins that line his studio walls and pulls out a trefoil crown and a round saucer-like element to demonstrate the range of shapes he is contemplating for the stoppers and covers for the pieces. From another bin, he produces a cardboard-mounted mock-up of a handle made by photocopying leafy rococo designs from a catalogue of decorative picture-framing elements. As he holds the handle up to the side of the largest model, one can begin to sense how the plaster's porcelain descendant will appear in its final incarnation on the Getty's center table.

The most dramatic transformation of the porcelains will be brought about, of course, by their surface treatment. For that aspect of the process, Saxe has engaged Gilles Bouttaz, a master painter from Sèvres, to assist him in producing the intricate abstract designs and faux finishes that will help to give each vessel a distinct personality and tie it to its eighteenth-century predecessors. Saxe, who is a great fan of wordplay, has given droll names to the decorative schemes. For a burled-walnut pattern, he invokes the nut-obsessed chipmunks of an old animated cartoon with *Le Noyer, for Chip and Dale*. He calls the chartreuse hue of another pattern *2CV Green*, a reference to the color of a Deux Chevaux car belonging to Bouttaz. Perhaps best of all is *Princess Cellulite*, the name he has given the bright-pink and gold faux marble decoration that will grace the most feminine-looking of the five pieces on the table. Additional flourishes of gold will be added to the royal mademoiselle and her companions, Saxe says, "to keep them in balance with the table and the torchères."

What effect does Saxe hope his sumptuous installation, with its multiple references, will have on viewers? The title he has chosen, *1-900-ZEITGEIST*, offers a partial answer. Beneath the comedic surface of the moniker's turn on the phone numbers assigned to psychics, sex workers, and political pollsters lies Saxe's serious intent. "This work gives some form to a metaphysical idea of being in a particular place at a particular time," he explains. "Now, on the cusp of the millennium," Saxe says, "I want to make a case for the anti-virtual, for being in the moment, for having a unique physical, sensate experience." And indeed, with a little help from the past, Saxe is capturing the spirit of the times.

53

ADRIAN SAXE
Plaster model for
centerpiece element from
1-900-ZEITGEIST, 2000

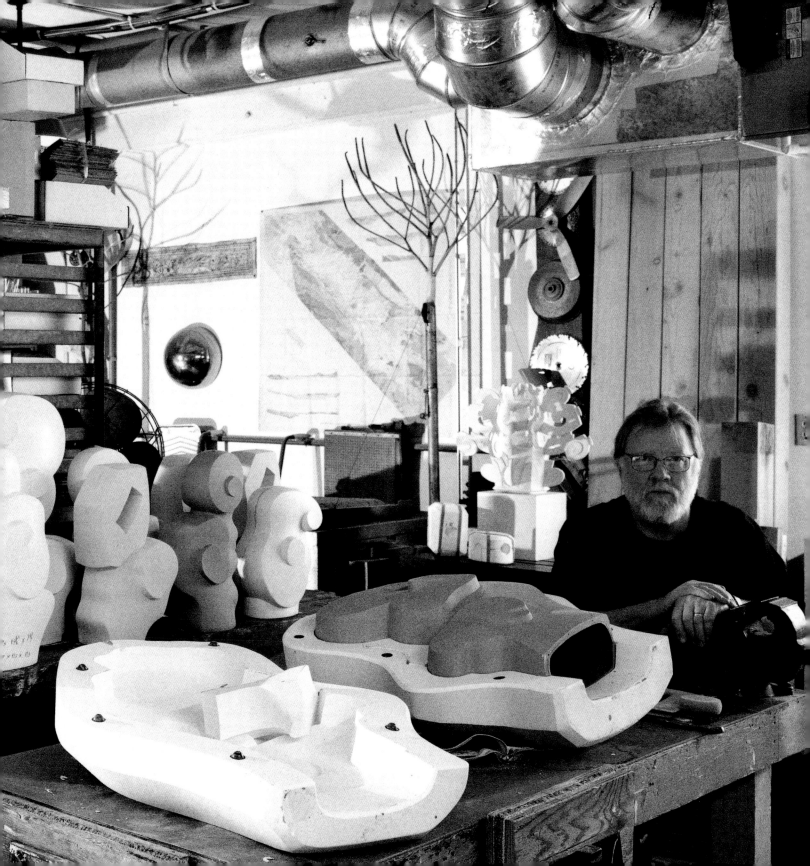

JOHN BALDESSARI

1. "News Lite: Meet the Beetle," *Daily News of Los Angeles*, Friday, August 20, 1999, section N, p. 2.
2. George R. Goldner with the assistance of Lee Hendrix and Gloria Williams. *European Drawings 1: Catalogue of the Collections The J. Paul Getty Museum* (Malibu: J. Paul Getty Museum, 1988), p. 290.

UTA BARTH

1. *The J. Paul Getty Museum Handbook of the Collections* (Los Angeles: J. Paul Getty Museum, 1997), p. 140.
2. Ibid.

SHARON ELLIS

1. For additional information, see Perrin Stein, "Caspar David Friedrich," in Burton B. Fredricksen, with additional text by David Jaffé, Denise Allen, Dawson W. Carr, Perrin Stein, *Masterpieces of Painting in the J. Paul Getty Museum* (Malibu: J. Paul Getty Museum, 1995), p. 46.
2. In George Benjamin Woods, *Poetry of the Victorian Period* (Chicago: Scott Foresman, 1930), pp. 711–12.

JUDY FISKIN

1. *Concert of Wills: Making the Getty Center*. Written and directed by Susan Froemke, Bob Eisenhardt, and Albert Maysles. 100 minutes, VHS format videocassette. Los Angeles, J. Paul Getty Trust, 1998.
2. All passages set as extract are from the artist's voice-over narration of the video *My Getty Center*.

MARTIN KERSELS

1. "Interview with Martin Kersels by Toby Kamps, January 1997, Madison, Wisconsin," in *Commotion: Martin Kersels* (Madison: Madison Art Center, 1997), p. 5.
2. Ibid., p. 4.
3. Ibid.
4. For further information on the Kouros, see *The Getty Kouros Colloquium: Athens, 25–27 May 1992*, ed. Angeliki Kokkou (Malibu: J. Paul Getty Museum, 1993). See also John Walsh and Deborah Gribbon, *The J. Paul Getty Museum and Its Collections: A Museum for the New Century* (Los Angeles: J. Paul Getty Museum, 1997), p. 138.

JOIIN M. MILLER

1. James H. Marrow, *The Hours of Simon de Varie* (Malibu: J. Paul Getty Museum, 1994), p. 61.
2. David Pagel, "Slow Thrills: Looking at John M. Miller's Paintings," *Art issues.*, January–February 1995, p. 11.

RUBÉN ORTIZ TORRES

1. For additional information on the car, see Jim Lewis, "Che Guevara's Chevrolet," *Art issues.*, March–April 1992, pp. 20–21.
2. James G. Cobb, "Behind the Wheel/2000 Chevrolet Impala: Apple Pie Without the Spice," *New York Times*, August 29, 1999, p. Y39.
3. Paul Duchene, "And If You'd Rather Have a Used Impala . . .," *New York Times*, August 29, 1999, p. Y39.

LARI PITTMAN

1. Perrin Stein, "James Ensor," in Fredricksen, op. cit., p. 48.
2. Christopher Knight, "Lari Pittman II," *Last Chance for Eden: Selected Art Criticism* (Los Angeles: The Foundation for Advanced Critical Studies, 1995), p. 158.

STEPHEN PRINA

1. Quoted in Kristine McKenna, "Getting His Chaos in Order," *Los Angeles Times*, January 21, 1996, Calendar Section, p. 69.
2. Prina's hand-inked musical score for the film will be on view in the exhibition gallery, along with a wall work comprising full-scale photographic reproductions of the La Tour and Honthorst paintings, framed under Plexiglas, that will bear the film's screening times and location in vinyl-cut letters.
3. The description of the film is based on the artist's written proposal for the project.
4. David Bourdon, *Warhol* (New York: Harry N. Abrams, 1989), pp. 202–203.

ALISON SAAR

1. *The J. Paul Getty Museum Handbook of the Collections* (Los Angeles: J. Paul Getty Museum, 1997), p. 26.
2. Ibid., pp. 20–21.
3. Ibid., p. 133.
4. Ibid., p. 26.

ADRIAN SAXE

1. Gillian Wilson, *Selections from the Decorative Arts in The J. Paul Getty Museum* (Malibu: J. Paul Getty Museum, 1983), p. 30.

WORKS COMMISSIONED
FOR THE EXHIBITION

Dimensions are given as height x width x depth.
Unless otherwise indicated, all works are lent by the artist.

JOHN BALDESSARI
Born June 17, 1931, National City, CA
Lives in Santa Monica, CA

Specimen (After Dürer)
2000
Ink-jet on canvas with UV coating, mounted on fiberglass
composite panel with stainless-steel T-pin
436.9 x 350.5 cm (172 x 138 in.)

UTA BARTH
Born January 29, 1958, Berlin, Germany
Lives in Los Angeles, CA

. . . and of time.
2000
Framed color photographs: a selection of diptychs and a
triptych from the series *. . . and of time.*
A 32-page soft-cover book with 20 color reproductions
serves as an index to the project; designed by Michael
Worthington with accompanying text by Timothy Martin.
Diptychs: 88.9 x 228.6 cm (35 x 90 in.) each
Triptych: 88.9 x 401.3 cm (35 x 158 in.)

SHARON ELLIS
Born October 28, 1955, Great Lakes, IL
Lives in Los Angeles, CA

A Vision of Spring in Winter
2000
Alkyd on canvas
121.9 x 152.4 cm (48 x 60 in.)
Lent by the artist, courtesy Christopher Grimes Gallery,
Santa Monica, CA

JUDY FISKIN
Born April 1, 1945, Chicago, IL
Lives in Los Angeles, CA

My Getty Center
2000
Video
16 minutes, 18 seconds

MARTIN KERSELS
Born February 2, 1960, Los Angeles, CA
Lives in Sierra Madre, CA

Kouros and me
2000
Four Cibachromes
127 x 182.9 cm (50 x 72 in.) each

JOHN M. MILLER
Born September 7, 1939, Lebanon, PA
Lives in Los Angeles, CA

All works are 1999, acrylic resin on canvas

Prophecy
228.6 x 350.5 cm (90 x 138 in.)

Sanctum
228.6 x 604.5 cm (90 x 228 in.)

Atonement
228.6 x 350.5 cm (90 x 138 in.)

RUBÉN ORTIZ TORRES
Born February 27, 1964, Mexico City, Mexico
Lives in Los Angeles, CA

La Zamba del Chevy
2000
3-D video projection and 1960 Chevrolet Impala lowrider

LARI PITTMAN
Born February 19, 1952, Glendale, CA
Lives in La Crescenta, CA

Indebted to you, I will have had understood the power of the wand over the scepter
> 2000
> Acrylic, alkyd, lacquer on mahogany panel
> 243.8 x 812.8 cm (96 x 320 in.)
> Lent by the artist, courtesy Regen Projects,
> Los Angeles, CA

STEPHEN PRINA
Born November 3, 1954, Galesburg, IL
Lives in Los Angeles, CA

Vinyl II
> 2000
> 16 mm film, color/sound
> 21 minutes, 30 seconds

Untitled (Vinyl II)
> 2000
> Two C-prints, cast vinyl computer film
> Left panel: 220.3 x 173.5 cm (87½ x 68⁵⁄₁₆ in.)
> Right panel: 85.7 x 141 cm (33¾ x 55½ in.)

Vinyl II, manuscript score
> 1999
> Ink, graphite on paper
> Six two-page sheets, 28 x 43 cm (11 x 17 in.) each

ALISON SAAR
Born February 5, 1956, Los Angeles, CA
Lives in Los Angeles, CA

Afro-di(e)ty
> 2000
> Mixed-media installation comprising wood figure with
> hammered copper and found objects, ink-jet on fabric
> 304.8 x 304.8 x 304.8 cm (120 x 120 x 120 in.)

ADRIAN SAXE
Born February 3, 1943, Glendale, CA
Lives in Los Angeles, CA

1-900-ZEITGEIST
> 2000
> Installation comprising Adrian Saxe six-part centerpiece
> on eighteenth-century center table with new marble-
> veneer top, and two Adrian Saxe vessels on a pair of
> eighteenth-century torchères
> Centerpiece and torchère vessels: porcelain, stoneware,
> noble metal lusters, overglaze enamels
> Centerpiece: approx. 91.4 x 76.2 x 116.8 cm (36 x 30 x 46
> in.) overall
> Torchère vessels: approx. 61 x 50.8 x 38.1 cm (24 x 20 x
> 15 in.) each

GETTY POINTS OF DEPARTURE

Dimensions are given as height x width x depth.

John Baldessari

ALBRECHT DÜRER (German, 1471–1528). *Stag Beetle*, 1505. Watercolor and gouache, 14.2 x 11.4 cm (5⁹/₁₆ x 4¹/₂ in.). Los Angeles, J. Paul Getty Museum, 83.GC.214.

Uta Barth

CLAUDE MONET (French, 1840–1926). *Wheatstacks, Snow Effect, Morning*, 1891. Oil on canvas, 65 x 100 cm (25¹/₂ x 39¹/₄ in.). Los Angeles, J. Paul Getty Museum, 95.PA.63.

ROBERT IRWIN (American, born 1928). Central Garden, 1997. Los Angeles, J. Paul Getty Trust.

Sharon Ellis

LAWRENCE ALMA-TADEMA (Dutch, 1836–1912; active in England from 1870). *Spring*, 1894. Oil on canvas, 178.4 x 80 cm (70¹/₂ x 31¹/₂ in.). Los Angeles, J. Paul Getty Museum, 72.PA.3.

CASPAR DAVID FRIEDRICH (German, 1774–1840). *A Walk at Dusk*, ca. 1830–35. Oil on canvas, 33.3 x 43.7 cm (13¹/₈ x 17³/₁₆ in.). Los Angeles, J. Paul Getty Museum, 93.PA.14.

ROBERT IRWIN (American, born 1928). Central Garden, 1997. Los Angeles, J. Paul Getty Trust.

WILLIAM HENRY FOX TALBOT (British, 1800–1877). *Oak Tree in Winter*, 1841. Salt print, image 18.4 x 16.6 cm (7⁵/₈ x 6¹⁷/₃₂ in.), sheet 22.4 x 18.8 cm (8¹³/₁₆ x 7³/₈ in.). Los Angeles, J. Paul Getty Museum, 84.XM.893.1.

Judy Fiskin

The Getty Center

Martin Kersels

Getty Kouros (young man). Greek, ca. 530 B.C., or modern forgery. Dolomitic marble from Thasos, H: 203 cm (79⁷/₈ in.). Malibu, J. Paul Getty Museum, 85.AA.40.

John M. Miller

JEAN FOUQUET *Simon de Varie in Prayer before the Virgin and Child*. Hours of Simon de Varie. Tours, 1455. Tempera and gold on parchment. Leaf, 11.5 x 8.2 cm (4¹/₂ x 3¹/₄ in.). Los Angeles, J. Paul Getty Museum, Ms. 7 (85.ML.27), fols. 1v–2.

Rubén Ortiz Torres

Views of Cuba during the Spanish-American War (1898). New York: Strohmeyer & Wyman, ca. 1899. Stereographs, 9 x 19 cm (3¹/₂ x 7¹/₂ in.). Los Angeles, Getty Research Institute, Research Library, 95.R.22.

Lari Pittman

JAMES ENSOR (Belgian, 1860–1949). *Christ's Entry into Brussels in 1889*, 1888. Oil on canvas, 252.5 x 430.5 cm (99¹/₂ x 169¹/₂ in.). Los Angeles, J. Paul Getty Museum, 87.PA.96.

Stephen Prina

GERRIT VAN HONTHORST (Dutch, 1590–1656). *Christ Crowned with Thorns*, ca. 1620. Oil on canvas, 220.3 x 173.5 cm (87¹/₂ x 68⁵/₁₆ in.). Los Angeles, J. Paul Getty Museum, 90.PA.26.

GEORGES DE LA TOUR (French, 1593–1652). *The Musicians' Brawl*, ca. 1625. Oil on canvas, 85.7 x 141 cm (33³/₄ x 55¹/₂ in.). Los Angeles, J. Paul Getty Museum, 72.PA.28.

Alison Saar

Hercules (Lansdowne Herakles). Roman, ca. A.D. 125. Marble, H: 193.5 cm (76¹/₈ in.). Malibu, J. Paul Getty Museum, 70.AA.109.

Adrian Saxe

Center Table. Support, French, ca. 1745; top, Italian, ca. 1600. Gessoed and gilded wood support; *pietre dure* and marble mosaic top. H: 87.6 cm (34¹/₂ in.), W: 197.1 cm (77⁵/₈ in.), D: 115.8 cm (45⁵/₈ in.). Los Angeles, J. Paul Getty Museum, 72.DA.58.

Pair of Torchères. Dutch, ca. 1740–50. Gessoed, gilded, and painted wood; crushed glass. H: 212.4 cm (83⁵/₈ in.), W: 68.6 cm (27 in.), D: 55.9 cm (22 in.). Los Angeles, J. Paul Getty Museum, 79.DA.5.1–2.

Page numbers in italics refer to illustrations.

abstract painting, 33

African antiquities, 48

Allen, Woody, 52

Alma-Tadema, Sir Lawrence

 Spring, 20, *20–21*, 58

anti-virtualism, 53

Aphrodite, 48–49

Art Moderne, 53

Baldessari, John, 58

 Specimen (After Dürer),
 12–13, *14–15*, 58

 *Study for "Specimen (After
 Dürer),"* 13, *13*

Barth, Uta, 58

 . . . and of time., *16–17*, *17*,
 18–19, 58

 nowhere near, 17

Botticelli, Sandro

 Birth of Venus, 49

Bouttaz, Gilles, 53

Burden, Chris, 28

Burgess, Anthony

 A Clockwork Orange, 45

Burroughs, William S., 13

Campodónico, Juan, 37

Carlevarijs, Luca, 25

Casacuberta, Carlos, 37

Center Table, 52, *52*, 59

ceramics, 52

Cervantes, Miguel, 28

Chandler, Raymond, 28

Chevy Impala, *36–37*, *37*,
 38–39

Chinese bronzes, 53

Chinese "scholar's rocks," 53

chinoiserie, 53

Cobb, James G., 36

Collins, Mary, 29

Conceptualism, 12, 44

*Concert of Wills: Making the
 Getty Center* (film), 24

contemporary artists, goals
 of, 12, 20

Costello, Elvis, 28

cross-culturalism, 36

Cuba, during Spanish-
 American War, 36,
 36–37, 59

Degonde, Jean-Luc, 53

de Varie, Simon, 32

Dürer, Albrecht

 Stag Beetle, 12, *12*, 58

Ellis, Sharon, 58

 Times of the Day, 21

 *A Vision of Spring in
 Winter*, 20–21, *21*,
 22–23, 58

Enlightenment, Age of, 52

Ensor, James

 *Christ's Entry into Brussels
 in 1889*, 40, *40–41*, 59

fantasy, 20

Fayum mummy portraits, 40,
 41

films

 by Andy Warhol, 45

 of Getty Center construc-
 tion, 24

 by Stephen Prina, 44–45,
 59

Fiskin, Judy, 58

 Diary of a Midlife Crisis, 24

 My Getty Center, *24–25*,
 26–27, 58

 rubber-band ball by, 24,
 25

Los Folkloristas, 37

Fouquet, Jean

 Hours of Simon de Varie,
 32, *32–33*, 58

Friedrich, Caspar David

 A Walk at Dusk, 20, *20–21*,
 58

garnitures, 52–53

Géricault, Théodore

 Portrait Study, 48

 The Raft of the Medusa, 48

German Romantic movement,
 20

Getty Kouros, *28*, 28–29, 58

Giotto di Bondone, 12

Goldberg, Rube, 28

Goya e Lucientes, Francisco
 José de, 12

Guevara, Ernesto "Che," 36,
 37

Havana, El Museo del
 Automóvile, 37

Hercules (Lansdowne
 Herakles), 48, *48*, 59

Hesiod, *Theogony*, 49

history

 construction of, 48

 contemporary interaction
 with, 29, 37

Hitchcock, Alfred, 28

homosexual polemics, 40, 41

Honthorst, Gerrit van

 *Christ Crowned with
 Thorns*, 44, *44*, 45, 59

Huillèt, Daniele, 45

Impressionism, 16

Irwin, Robert

 Central Garden, Getty
 Center, 11, *16*, 17, 21, 58

Jara, Victor, 37

Joshua Tree National Park, 21

Keaton, Buster, 28

Kersels, Martin, 58

 *Attempt to Raise the
 Temperature of a
 Container of Water by
 Yelling at It*, 28

 Piano Drag, 28

 Tossing a Friend, 28

 Twist, 28

 Untitled (Kouros and me),
 29, *29*, *30–31*, 58

 Whirling Photos series, 28

Klein, Yves, 28

Knight, Christopher, 41

Kouros

 Greek, *28*, 28–29, 58

 Kersels's photographs of,
 29, *29*, *30–31*, 58

La Tour, Georges de

 *Christ with Saint Joseph in
 the Carpenter's Shop*, 44

 The Musicians' Brawl, 44,
 44–45, 59

Lichtenstein, Roy, 41

light, study of, 16, 21

Los Angeles, Getty Center

 Central Garden, *16*, 17, 21,
 58

 Central Garden inscription,
 17

 construction of, 24, *24*

 Getty Research Institute
 (GRI), 10, 36

 J. Paul Getty Museum, 10

lowriders, 36, 37

magic, 40

Magritte, René, 13

Malanga, Gerard, 45

mannerism, 40

manuscripts, 32

Marc, Franz

 Die grossen blauen Pferde
 (The Large Blue
 Horses), 9, *9*

Marrow, James H., 32

Martin, Timothy, 58

McLane, Kelly, 29

Meier, Richard, 25

metaphors, 40

Miller, John M., 58

 Atonement, 33, 58

 Prophecy, 33, *33*, *34–35*, 58

 Sanctum, 33, 58

Minneapolis

 Minneapolis Institute of
 Arts, *Jade Mountain
 Illustrating the
 Gathering of Poets at the
 Lan T'ing Pavilion*, 9, *9*

 Walker Art Center, 9

modernism, 25, 52

Momoyama period, Japan, 52

Monet, Claude

 *Wheatstacks, Snow Effect,
 Morning*, *16*, 16–17, 58

Monty Python's Flying Circus,
 28

Muñoz, Salvador "Chava," 37

museum installation prac-
 tices, commentary on, 13

naturalism, 20

Nelson, George, 16

El Niño, 24–25

Ortiz Fernández, Rubén

 La Zamba del Che, 37

Ortiz Torres, Rubén, 59

 Alien Toy, 37

 La Zamba del Chevy, 36–37,
 37, *38–39*, 59

Pagel, David, 33

Pankin, Jared, 29

Pasadena (CA), Norton Simon
 Museum, 10

perception, study of, 16, 17

performance art ("performa-
 tive objects"), 28

photographs, Barth's visual
 index of, 16, 58

Pittman, Lari, 59

 *Indebted to you, I will have
 had understood the
 power of the wand over
 the scepter*, 40–41, *41*,
 42–43, 59

 *Untitled #1 (A Decorated
 Chronology of Insistence
 and Resignation)*, 41

Pop art, 41

postmodernism, 52

Prina, Stephen, 59

 Vinyl II, 44–45, *45*, *46–47*,
 59

realism, 20

repetition, 17

Rococo, 52

Rosenquist, James, 41

Rubens, Peter Paul

 The Entombment, 10, *11*, 45

Runge, Philip Otto, 21

Saar, Alison, 59

 Afro-di(e)ty, 48–49, *49*,
 50–51, 59

 Study for "Afro-di(e)ty,"
 49

Saxe, Adrian, 59

 1-900-ZEITGEIST, 52–53,
 53, *54–55*, 59

Schoenberg, Arnold, 44

scientific naturalism, 12

sci-fi horror cinema, 13

sculpture

 Getty Kouros, *28*, 28–29

 mixed-media, 48–49

 objectification of, 13

 performative, 28

Seurat, Georges

 *Sunday Afternoon on the
 Island of the Grande
 Jatte*, 40

Sèvres pottery, 52

Shore, Dinah, 36

SHRIMPS collaborative, 28

Snow, Michael

 Wavelength, 45

space, study of, 32–33

Spanish-American War, 36,
 36–37, 59

spectatorship, 45

stereographic photographs,
 36, *36–37*

Straub, Jean-Marie, 45

Streisand, Barbra, imperson-
 ators of, 41

surrealism, 13

Swinburne, Algernon Charles

 Dedication, 21

 *A Vision of Spring in
 Winter*, 21

Talbot, William Henry Fox

 Oak Tree in Winter, 20, *21*,
 21, 58

theatricality, 41

time (duration), study of,
 16–17, 32–33

Tivoli, Hadrian's villa at, 48

Torchères, Dutch (ca.
 1740–50), 52, *52*, 59

trompe l'oeil illusionism, 13

videos

 by Judy Fiskin, 24

 by Rubén Ortiz Torres, 37

Vienna, Albertina Museum, 12

Walker, Thomas Barlow, 9

Warhol, Andy, 45

Wenders, Wim, 28

wordplay, 28, 53

Worthington, Michael, 58

Yemaya, worship of, 49

Yoruba tribe, 49

zamba music, 37

Zurbarán, Francisco de

 *Still Life with Lemons,
 Oranges and a Rose*, 10,
 10

ACKNOWLEDGMENTS

There are few things more soul satisfying for a contemporary curator than being party to the genesis of a major work of art. I feel especially blessed to have had the opportunity to be in that unique position eleven times over with the outstanding artists represented in this exhibition: John Baldessari, Uta Barth, Sharon Ellis, Judy Fiskin, Martin Kersels, John M. Miller, Rubén Ortiz Torres, Lari Pittman, Stephen Prina, Alison Saar, and Adrian Saxe. I am grateful to them for dedicating precious months to producing new works especially for this project, and for patiently submitting to several rounds of questioning and hours of conversation about their creations.

Thanks are also due the artists' representatives, all those individuals and organizations who assisted in the realization of the artists' projects, and the many people who provided consultation, information, and research materials that were crucial to the success of this project. Their names appear here, organized by artist:

JOHN BALDESSARI: Carlson & Company; Michael Charvet; Matt Furmanski; Olson Color Expansion; Kim Schoenstadt.

UTA BARTH: Robert Gunderman and Randy Sommers, ACME., Los Angeles; Tim Martin; Michael Worthington.

SHARON ELLIS: Christopher Grimes and David Mather, Christopher Grimes Gallery; Michael Solway; Christopher Weir.

JUDY FISKIN: Mike Jarmon; Peter Kirby, Media Arts Services; David Wilson.

MARTIN KERSELS: Debi Albeyta; Mary Collins; Kelly McLane; Jared Pankin; Rik Paul.

JOHN M. MILLER: Patricia Faure, Patricia Faure Gallery, Santa Monica; Martin Muller, Modernism Gallery, San Francisco; Horacio M. Ocampo, Lucius Hudson, Inc.; Mike Vegas.

RUBÉN ORTIZ TORRES: Pedro Alvarez; Dermot Begley; Carlos Casacuberta and Juan Campodónico; El Gallo Pintor; Chico Gonzales; Peter Kirby, Media Arts Services; Michael Kowalski; Laser Pacific; Jesse Lerner; Patrick Miller; Todd Moore; Salvador "Chava" Muñoz; Rubén Ortiz Fernández; Tony Ortiz, Back Yard Boogie.

LARI PITTMAN: Shaun Caley Regen and Lisa Overduin, Regen Projects, Los Angeles.

STEPHEN PRINA: Margo Leavin and Wendy Brandow, Margo Leavin Gallery, Los Angeles; Friedrich Petzel Gallery, New York; Galerie Gisela Capitain, Koln, Germany; Jennifer Lane; David Hollander; Gary Todd.

ALISON SAAR: Mitra Fabian; Thomas Leeser; Caitlin Wilbur.

ADRIAN SAXE: Gilles Bouttaz; Jean-Luc Degonde.

The staff of the J. Paul Getty Museum, an institution so adept at dealing with art of the past, gamely ventured into the new and unfamiliar territory of contemporary art, and for that I am grateful. I most especially want to thank John Walsh, the Museum's director, and Deborah Gribbon, Deputy Director and Chief Curator, for inviting me to undertake this project and for placing their confidence in me. Thanks are also due the curators of the Museum and the Getty Research

Institute's various collections who shared their knowledge with the artists and me.

My sincere appreciation goes to Quincy Houghton, Exhibitions Manager, and the other members of the Exhibitions Department, Amber Keller, Exhibitions Coordinator, Kevin Murphy, Staff Assistant, and Graduate Intern Yves Theoret, who shepherded the project through the Museum's corridors every step of the way, with valuable input from Barbara Whitney, Associate Director for Administration and Public Affairs. I also wish to thank Mark Greenberg, Managing Editor, Museum Publications, and the staff of Trust Publications Services, including Deenie Yudell, Design Manager, Karen Schmidt, Production Manager, and Amita Molloy, Production Coordinator, without whom this catalogue would not have been possible. Merritt Price, Exhibition Design Manager, Tim McNeil, Senior Designer, and Mary Beth Trautwein, Designer, did a superb job of designing the exhibition installation and related materials. I am also appreciative of the contributions of the many other staff members who assisted in the realization of the exhibition: Brian Considine, Conservator of Decorative Arts and Sculpture; Sally Hibbard, Registrar, and Alicia Thomas, Assistant Registrar; Bruce Metro, Head of Preparations; Lori Starr, Director, Public Affairs, and Karen Nelson, Senior Public Affairs Associate; Libby Rogers, Museum Marketing and Communications Associate; Cathy Carpenter, Education Specialist; Amy Fisk, Administrative Assistant; and Penny Pittman Cobey, Acting General Counsel, J. Paul Getty Trust.

Lorraine Wild developed the ingenious graphic identity for the exhibition and, with the help of Amanda Washburn, designed its catalogue, which Tobi Kaplan expertly edited. Special acknowledgment is due the exhibition's "Fifth Beatle," Grant Mudford, who produced the superb photographic portraits of the eleven artists that appear in this catalogue and in the exhibition. Most of all, my thanks go to my husband, Richard Grossman, for his loving support.

Lisa Lyons
Guest Curator

Photo Credits

John Baldessari: p. 13. Claire Curran: p. 16 bottom, © J. Paul Getty Trust. Jennifer Lane: p. 45. Lou Meluso: pp. 11, 16 top, 20 bottom, 40, 44 top and bottom. Patrick Miller: p. 37. Grant Mudford: pp. 14–15, 18–19, 21 bottom, 22–23, 25, 26–27, 29, 30–31, 33, 34–35, 38–39, 41, 42–43, 46–47, 49, 50–51, 53, 54–55. Charles Passela: pp. 12, 32. Ellen Rosenbery: pp. 21 top, 48. Jack Ross: pp. 24 bottom, 52 bottom. John Stephens: p. 24 top, © J. Paul Getty Trust.